IMAGES
of America

AFRICAN AMERICANS
OF ROUND TOP

IMAGES
of America

AFRICAN AMERICANS
OF ROUND TOP

David L. Collins Sr.

ARCADIA
PUBLISHING

Published by Arcadia Publishing
Charleston, South Carolina

Printed in the United States of America

Library of Congress Control Number: 2023941951

For all general information, please contact Arcadia Publishing:
Telephone 843-853-2070
Fax 843-853-0044
E-mail sales@arcadiapublishing.com

Visit us on the Internet at www.arcadiapublishing.com

To Doris Dunbar Collins and Maggie Lee Taylor, whose unending struggles never dimmed their hope for a brighter future for their children. In honor of my father, who witnessed the most pivotal moment in American history—Hiroshima and Nagasaki—and to my grandparents, who were steadfast Fayette County pioneers.

CONTENTS

ACKNOWLEDGMENTS

I would like to personally thank the many individuals who helped make this Round Top, Texas, history a reality. A very special thank you to my parents, Doris Dunbar Collins and Maggie Taylor; my aunt Katie Taylor-Griffin; my grandfather Wesley Taylor; Georgia Etzel-Tubbs; and Herbert L. Diers, cofounder of the Round Top Area Historical Society of Round Top, Texas.

I am very grateful to the many pioneers who willingly shared their personal pictures, stories, and historical information with me. A heartfelt thank-you goes to Beatrice Crump-Rivers, daughter-in-law of David Rivers, "the Colored Chicken Farmer of Fayette County"; Malissa Hoson-Rivers, wife of David Rivers; Olivette Clemons-Shepard; James Walter Dobbins; Rose Diers; Loraine Craft-Cole, the longtime secretary of the Concord Missionary Baptist Church; Pearline Knotts-Burrell, Round Top Negro High School teacher; Clarence Phoenix; Billy Beth Roberts; Leo Vaugh Sr.; R.L. Homer; Bobbie Houston; Josephine White; Judy Matejowsky; Marie Watts; Wilburn Hackebeil; Pamela Collins; Gene O. Collins; Hubert Collins; Yulanda Fletcher-Thurman; Lena Katheryn McNeal; Lena Bird; Hattie Taylor-Ray; James Wesley Taylor; Hattie Mae Taylor; Mattie Ray-Davis; Lafayette Collins; Lilian Stuermer-Dyer; Wesley Davis; Leola Taylor; Cordell Levein; Dottie Etzel; Delores Etzel; Neale Rabensburg; Jennifer Kitchen; Gene Menken; Ruth Fricke; Harley Weyand; Jeannette Burger; Sue Foster; Herman Ferguson; Juanita Rivers-Ferguson; Patricia Hansen; Earline Johnson-Carter; and Robert Willrich.

I would like to acknowledge my archive sources. A thank-you goes to the Fayette County Texas Deed Records and Archives; the Texas General Land Office, Austin, Texas; and the Round Top Area Historical Society Archives.

Lastly, I would like to say a thank-you to my editing consultant, Gloria Ballenger Rainwater.

Unless otherwise noted, all images are courtesy of David L. Collins.

INTRODUCTION

Decades of travel, both business and personal, both national and international, have contributed to my lifelong interest in the African diaspora. They have also contributed to my interest in my ancestors' hometown of Round Top, Texas—specifically, my interest in Round Top's African American history.

In each place I have visited, as distant from Saudi Arabia to London, to France, to Italy, to Brazil, to Haiti and beyond, I have always tried to visualize and learn about the African presence in these places—a presence, in most instances, caused by slavery. Pioneers of African descent first arrived in America over 500 years ago, before 1619 in Jamestown. The earliest known free person of African descent to arrive in America was the Black conquistador Juan Garrido, who accompanied Ponce de Leon to the Florida coast in 1513.

The first known enslaved person of African descent to arrive in Texas was Esteban the Moor. In 1528, Esteban was an important member of the Narvaez Expedition, which fatefully found its way to mainland Galveston. On my work visits to Corpus Christi, Texas, as I and my work colleagues strolled along the Shoreline Boulevard overlooking the Gulf, I noticed a bronze plaque that read "Explorer de Vaca, two Spaniards and a Black Moor." This mention of an African explorer awakened an interest in finding out more about African American contributions to the history of America—particularly their contributions to rural America in small towns such as Round Top, Texas.

This interest inspired me to go in search of that history by driving the back roads of Fayette, Lee, and Bastrop Counties from county line to county line. A part of that search for history also involved searching for the many names of the enslaved pioneers that have been lost to time. These people helped build small-town America, and their names deserve to be remembered. I searched for these unsung pioneers by visiting many cemeteries in both Fayette and Lee Counties. The cemeteries I visited in Lee County were Jones Colony, Globe Hill, Salem, Sweet Home, Antioch, Sandy Point, Pilgrim Rest, Post Oak, and Sandy Point Church Cemetery. The ones I visited in Fayette County were La Grange City Cemetery, Richter, La Bahia, Hill Family Cemetery, Armstrong Colony, Connersville Primitive Baptist Church Cemetery, and Cozy Corner Cemetery in south La Grange, Texas. Cozy Corner and Armstrong Colony are two Freedom Colonies located in Fayette County, Texas.

While visiting the Connersville Primitive Baptist Church Cemetery, I came upon the graves of George Craft, born in 1850, and a relative on my own family tree, Emma Rivers, born in 1878. This particular visit not only led me to new names to add to my collection of Round Top pioneers, it also led me to a very solemn surprise. On one of the headstones was the inscription "In the Back Woods We Lay . . ."

That inscription was the motivation for this book. Finding locally written history books that cover the lives of African Americans who lived in small-town rural America is rare. Counties such as Lee and Fayette have a rich African American history. Small towns like Ledbetter, Texas, have

African American stories that have never been told. These stories need to be told to give a voice to those who contributed to the building of this country.

The 1947 Fayette County Land Ownership map indicates that there were 36 African American landowners and residents within a five-mile radius of Round Top, Texas. Those landowners were William Moore, Lufkin Davis, Ollie Walker, Cornelius Walker, Israel Crump, Henry and Sarah Wade, Adam and Emmerline Rivers, Thomas and Ellen Rivers, C.L. Rhone, Antonio Garcia, Cyrus McCoy, P.W. Vincent, J.S. Sampson, Oscar Knotts, Sam Chattman and Lucy Rivers, J.C. Knotts, J.S. Simpson, E. Martin, William and Alice Rivers, Lafayette and Rachel Rivers and John Rivers Sr., Sam Washington, S.A. Sampson, W.C. Knotts, Andrew Knotts and Oscar Knotts, J.S. Knotts, William Banks, Perry Dobbins, and E.C. Kraft (Craft).

Some of these landowners were descendants of Round Top's original enslaved pioneers. Pioneers were bought into Texas when the Mexican government, between 1831 and 1835, began granting leagues of land to Anglo-Americans. The names of a few of those early Anglo Tejas settlers who benefited from those grants were: A.E. Baker, Green Dewitt, Mary Phelps, W.S. Townsend, John Townsend, John Logan, Robert P. Shaw, N. Townsend, W.J. Russell, J.G. Wilkinson, and John Vanderworth.

Of particular historical interest to this African American Round Top pioneering history are leagues of land where pioneering enslavers such as William Hamilton Ledbetter and Christopher H. Taylor settled. Some of their contemporaries, who were also responsible for bringing in enslaved Round Top pioneers, were W.F. Wade, John R. Robison, and Samuel K. Lewis.

These settlers may have been attracted to this land because Round Top is a very charming and picturesque area. It sits on a hill nestled between Cummins Creek to the southwest and the oak tree–lined Rocky Creek to the east, both of which are Colorado River tributaries. It is no wonder that many of the original settlers and the Round Top African American pioneers, once they were freed, chose to settle in this area.

After the Civil War ended, African Americans began the journey to establish their own communities in Fayette County and other counties. Texas historians refer to these communities as Freedom Colonies. This book will take the reader on a journey to help explain the making of the Freedom Colonies in the Round Top area.

But first, the uncomfortable part of that historical journey has to be told. The 1870 census is referred to as the "Brick Wall" by African American genealogists. It is called the Brick Wall because the names of African Americans prior to 1870 were not listed in Southern federal census records. They were not listed because, during the antebellum era, Article 1, Section 2, of the Constitution of the United States stated that any person who was not free should be counted as three-fifths of a free person for the purposes of determining congressional representation.

When the 1850 federal census was taken, instead of listing American residents by family, for the first time the census records listed free residents individually. Those who owned enslaved pioneers were given a second census to fill out. Listed on that second census was the name of the owner of the enslaved pioneers, the number of pioneers enslaved, their age, sex, color, if an enslaved person ran away, if the owner manumitted anyone, and if any enslaved person was handicapped. Enslaved pioneers were not considered persons in the 1850 and 1860 censuses because, to their owners, they were mere chattel. This did not officially change until 1868, when the Constitution was amended. The year 1870 saw the first time in Southern American history that enslaved persons were legally listed by name and family in a federal census.

Black pioneers were in Texas in its earliest founding days. However, writing about them is challenging because their names and their deeds were purposefully never recorded. Histories such as this one are an attempt to right that wrong.

One

EARLY AFRICAN
AMERICAN PRESENCE

Round Top, Texas, enslaved pioneer history began in 1821, when Anglo settlers began migrating to the Round Top, Fayette County, Texas area from Southern slaveholding regions of the United States. Texas scholars often refer to Texas in the years 1821 through 1836 as Mexican Texas. By 1821, Mexico had won its independence from Spain. A few years later, in 1824, the United Mexican States, via its constitution, joined Texas with Coahuila to form the state of Coahuila y Texas. For governmental reasons, Fayette County was divided into the municipalities of Colorado (present day Colorado County) and Mina (present day Bastrop County). Texan legend Stephen F. Austin was the second and most successful empresario to receive a grant from the Spanish government to bring settlers into Texas. When the Mexican War for Independence ended, the Mexican government ratified the grant. One of the land grants of historical interest to Round Top enslaved pioneer history is the James Winn grant because of its future ties to African American Freedom Colonies in and around Round Top. When empresarios began bringing settlers and the pioneers they enslaved into Texas, the Mexican government was confronted with the problem of slavery. One of the ways that Mexico decided to address this issue was in 1822 in one of the earlier drafts of Mexico's colonization laws that stated enslaved pioneers were not to be sold or purchased within the Mexican empire and that any children born within the empire shall be free at the age of 14. Anastasio Bustamante, Mexico's fourth president, passed an 1830 law that banned settlers from any further transport of slaves into Mexican territory. To try and circumvent this law, many Texas Anglo colonists, aware of Mexico's system of debt peonage, decided to, on paper, change the status of the pioneers they enslaved to indentured servants or day laborers.

El Ciudadano **MIGUEL AROINEGA**, Comisionado nombrado por el Supremo Gobierno de este Estado, para el repartimiento y posesion de tierras, y espedicion de titulos a los nuevos Colonos en la empresa de colonizacion del Empresario Ciudadano Estevan F. Austin fuera de las diez leguas litorales de la Costa:

POR cuanto se ha recibido _____ como colono en la empresa de colonizacion contratada con el Gobierno del Estado de Coahuila y Tejas por el Empresario Estevan F. Austin en _____ de _____ de 18__ como consta en folio ___ de este libro becerro y habiendo el dicho _____ justificado que es _____ y encontrarse en su persona los requisitos que previene la ley de colonizacion del Estado de 24 de Marzo de 1825; de conformidad con la citada ley, y las instrucciones que me rijen de fecha 4 de Septiembre de 1827, y articulo adicional de fecha 20 de Abril del año pasado de 1830 y en el nombre del Estado, concedo, confiero y meto en posesion real y personal de _____ de tierra al mencionado _____ cuyo terreno ha sido medido por el agrimensor _____ nombrado previamente al intento bajo la mensura y linderos siguientes _____

The arrival into Texas of empresario Stephen F. Austin and his new settlers was not the beginning of Texas history. Texas history began when the Spanish government began issuing land grants to Spanish colonists in the late 18th and early 19th centuries. The descendants of these colonists would come to be known as Tejanos. However, to most Texans raised on the lore of Stephen F. Austin, Texas history began when Anglo settlers like James Winn came into Texas. On March 31, 1831, James Winn was awarded this Fayette County land grant patent from the State of Coahuila. Part of it says in English, "Citizen Miquel Aroinego, Commissioner appointed by the Supreme Government of this state, for the distribution and possession of land, and issuance of titles to the new settlers in the colonization enterprise of the Citizen Businessman Estevan F. Austin." (Above, courtesy Texas General Land Grant Office; below, courtesy Wikimedia Commons, University of Texas at Arlington Libraries Special Collections, gift of Jenkins Garret.)

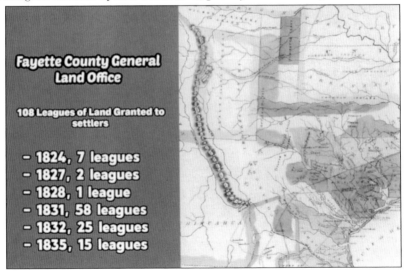

Fayette County General Land Office

108 Leagues of Land Granted to settlers

- 1824, 7 leagues
- 1827, 2 leagues
- 1828, 1 league
- 1831, 58 leagues
- 1832, 25 leagues
- 1835, 15 leagues

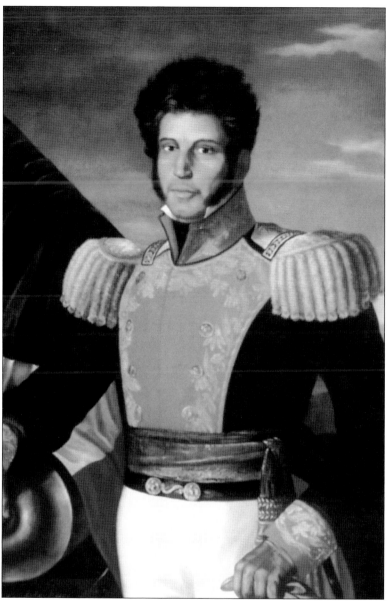

Vicente Ramon Guerrero was born in 1792 in Tixtla, a town just outside the port of Acapulco. When he was in his 20s, he worked as a gunsmith in Tixla, and after a Mexican revolt broke out against Spain, he quickly joined the fight for Mexican independence, where he rose to the rank of general. In 1829, he became Mexico's second president. Some scholars believe that Vincente Guerrero was of mixed race having both African and Indigenous lineage. In 1829, he issued the Guerrero Decree, which prohibited slavery in many parts of Mexico. This was a problem for Stephen F. Austin, because many of his colonists who were willing to emigrate to Tejas were slaveholding colonists. Austin, in his plea to the Mexican government, warned that if any of his prospective colonists were to free the people they enslaved before emigrating, this could leave many of the colonists financially destitute. In order to temporarily appease Stephen F. Austin and his new Tejas settlers, Guerrero did decide to grant them a one-year exemption from the 1829 edict outlawing slavery (Courtesy Wikimedia Commons, Palacio Nacional, Mexico.)

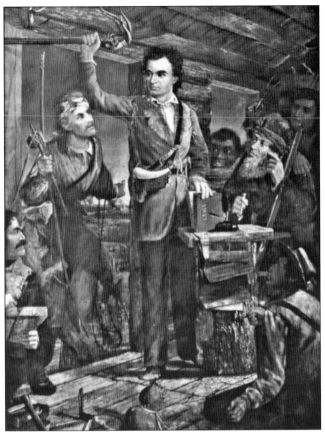

By 1834, Texas had about 2,000 enslaved pioneers. Texas could not have grown economically without enslaved labor to cultivate the land, particularly for cotton. Empresario Austin understood that if Mexico banned slavery in Tejas, recent Southern colonists might leave and he would have a problem attracting new colonists. One of his arguments to the Mexican government was that freeing slaves could leave colonists destitute. Because of the incessant slavery negotiations between Mexico and Stephen F. Austin, Austin wrote in one of his papers that he believed that Texas needed to become a slave country. This written entry in his papers, some scholars believe, may have been one of the reasons behind Texas becoming a republic. (Left, courtesy Library of Congress; below, courtesy slaveryimages. org/s/slaveryimages/item/1149.)

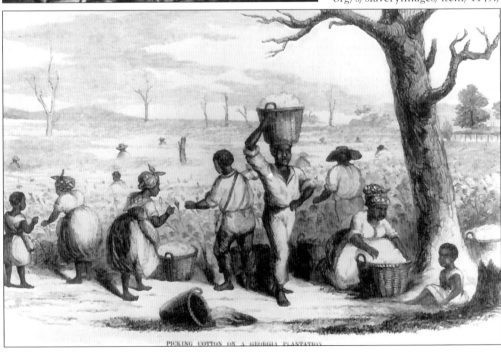

PICKING COTTON ON A GEORGIA PLANTATION

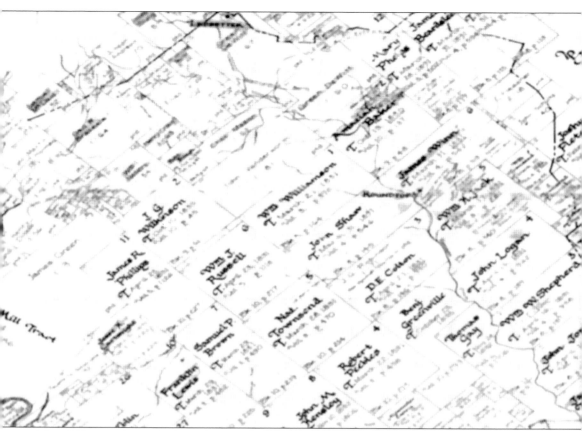

This 1878 map shows the boundary of all leagues of land surrounding the town of Round Top that were granted by the Mexican government prior to the Texas Revolution of 1836. Among the settlers who came in and received leagues of land during this period that helped shape Round Top's future were William Williamson, Amaziah Baker, Mary Phelps, C. Fleasher, John Schultz, Joshua Fletcher, William Townsend, J. Townsend, John Logan, Benjamin Greenville, D.E. Colton, William H. Jack, John Shaw, and James Winn (Round Top, Texas, was incorporated into James Winn's league). These new Anglo settlers who came to Texas found themselves at odds with the Mexican government. There were many reasons for this: culturally they were American; the Mexican government was unstable; they were unwilling to free the enslaved pioneers they bought with them; and various economic reasons. (Courtesy Texas General Land Grant Office.)

Anglos were not the first settlers in Texas. Bessie Katherine Collins married the descendant of a Spanish settler, or Tejano. Shown is the man's father, Frank Garcia. Frank was born on November 4, 1878, in Guadalupe County. His father, Ben (Benito) Garcia, was born in Mexico in 1835. Ben's mother was thought to be named Anna Garcia and was born in Spanish Mexico in 1805. During slavery, Benito Garcia began a relationship with an African American woman named Belle Saunders, who was born in the slave-holding state of Missouri in 1845. They had their first child, named Rachel, in Guadalupe County in 1862. In the 19th and into the mid-20th century, America had a one-drop rule regarding racial classification. This concept was codified into law in the form of legal slavery and post-slavery into America's caste system of segregation. In 1870, when Ben and Belle married, Ben was listed as White on the census, and his wife, Belle, and son Frank were listed as Black. Frank died in Lee County, Texas, in 1943.

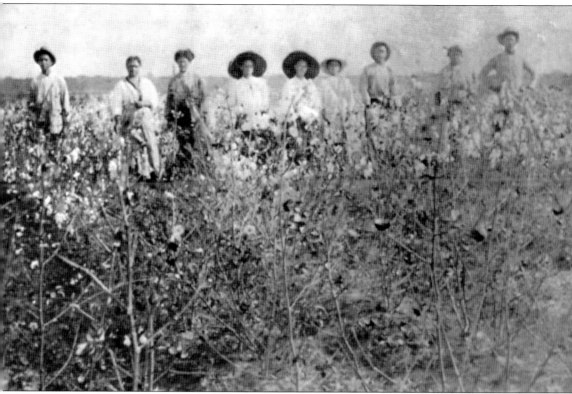

Based on the perceived age of these unidentified pioneering Round Top residents seen standing in a cotton field, some of them may have been born into slavery when Texas was young. When Stephen F. Austin bought the new settlers into Texas, part of the incentive for them to come was listed in Austin's contract. For each enslaved person that a settler bought in, they would be given anywhere from 50 to 80 acres of land. These new enslaved pioneers came into an untamed, hostile environment. Preparing the land for cultivation was backbreaking work. While clearing the land, they were exposed to often hidden and unseen dangers such as rattlesnakes and venomous spiders. Many had to work long hours in the hot sun while suffering from exposure to poison ivy. Some were victimized by Native American raids on a planter's property. Both the Cherokee and Creek tribes in Indian Territory were slave-holding tribes. Consequently, if the enslaved person were captured during a Comanche attack, the Comanche would either kill them or sell them. (Courtesy Della Catley-Franklin.)

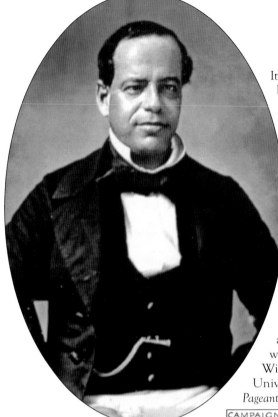

It did not take long for tensions to boil over between the Mexicans and the new Texas settlers. Stephen F. Austin was troubled by several things during his era. He thought, as did many others during his time, that slavery was a necessary evil. He made known his fears that the South, especially Texas, could someday become "Santo Domingonized"—he meant the Haitian Revolution. He was also troubled when Santa Anna in 1835 repealed the Mexican constitution, saying that American settlers were not really supporting the Mexican government by paying taxes. However, it was widely believed that the repeal was in response to some Americans wanting to buy Texas. Tensions came to a boiling point when Santa Anna marched into Texas as a show of force, and then things escalated with the Battle of the Alamo. (Left, courtesy Wikimedia Commons, Southern Methodist University Digital Collections; below, courtesy *Pageant of America, Vol. 2: The Lure of the Frontier*.)

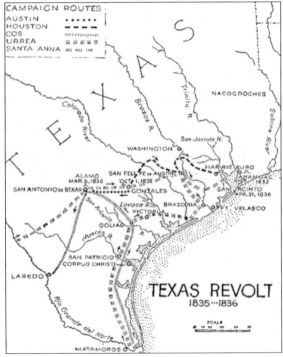

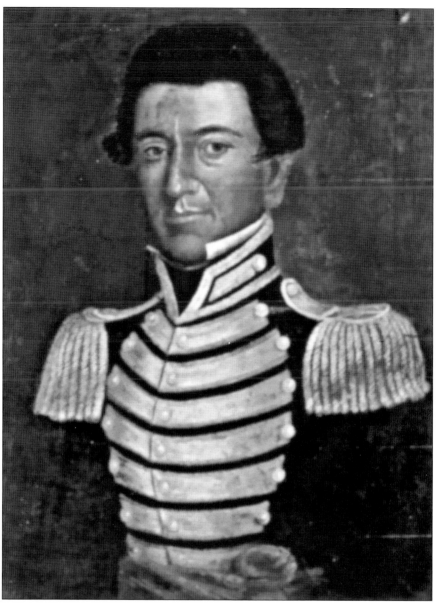

One of Santa Anna's opponents was a Spanish Tejano known as Juan Nepomucena Sequin, who was born in 1806 in San Antonio de Bexar, Province of Texas. His parents were Spaniards from the Canary Islands. His father was a postal administrator. Having grown up in Texas, Sequin's allegiance was more with the American colonists than it was with the Mexican government. He was especially critical of the government when it repealed the Mexican Constitution of 1824, because he believed that slavery was imperative to the economy of Texas. When the Texas Revolution broke out, he and about 160 rancheros participated in the famous Siege of Bexar. By 1836, he had become commissioned as a captain in the regular Texas army. Although he fought in the Battle of the Alamo, because he was chosen to be a messenger behind enemy lines, he was not present at the final fated battle. Pioneers such as Sequins and the Garcias, just like their Anglo and enslaved counterparts, helped settle the Texas frontier. (Courtesy Wikimedia Commons, Texas State Library and Archives Commission.)

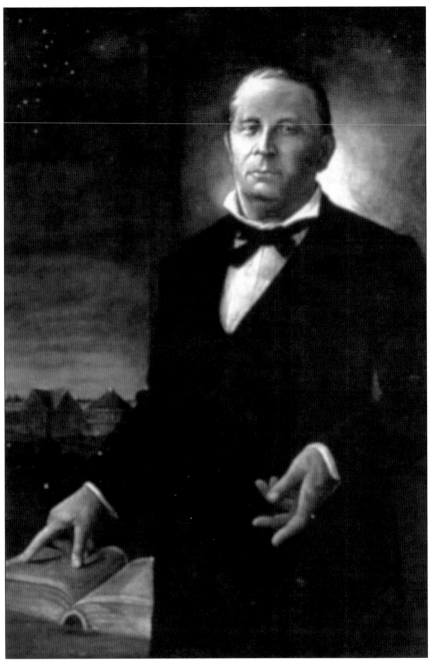

Although no major Texas Revolution battles were fought in or around Round Top, there were Round Top residents who fought in the Texas Revolution and who were Texas independence heroes. In 1833, enslaver John Robison had a league of land on Cummins Creek in Fayette County. In 1836, he was killed in Round Top by Native Americans. His son Joel Robinson was a Texas independence hero. Joel took part in the Siege of Bexar in 1835 and fought in the famous Battle of San Jacinto. In August 1881, while living in Round Top, Joel wrote a letter to the president of Baylor University, William Carey Crane (shown), detailing the capture of Santa Anna in 1836. (Courtesy Wikimedia Commons, Baylor University Digital Collections.)

In William Carey Crane's 1881 Round Top letter to Joel Robinson, he recounts details of the Battle of San Jacinto. He boasted that when he first saw the hostile Mexican army, he remained on horseback to become a target exposed to artillery. He recounted how his horse's bridle was struck by a shot and that as he rode, cannonballs were cutting tree branches down above his head. Before the battle, he said he had been so vigilant in waiting for the Mexican army that he had not bothered eating and that his staff had to implore him to eat. He talked about how difficult it was to eat the beef. He mentioned the fall of the Alamo and how some men deserted because of it. He said he and his men were half-armed and half-clad as they waited for the enemy. (Both, courtesy Library of Congress.)

LIFE

AND

SELECT LITERARY REMAINS

OF

SAM HOUSTON,
OF TEXAS.

TWO VOLS. IN ONE.

BY

WILLIAM CAREY CRANE, D.D., LL.D.,
President of the Baylor University, Independence, Texas.

PHILADELPHIA:
J. B. LIPPINCOTT & CO.
1884.

CHAPTER IX.

THE BATTLE OF SAN JACINTO—THE HERO CHIEFTAIN AND THE HERO SOLDIERS—
GEN. HOUSTON'S REPORT—COL. ROBISON'S REPORT OF CAPTURE OF SANTA ANNA—
T. HOUSTON'S ADDRESS AND EXERCISES AT UNVEILING OF MEMORIAL MONUMENT.

THE night which preceded the bloody battle of San Jacinto exhibited one man over whose mind there passed no anxious vision. Witnessing the first meeting of the hostile armies, he had remained on horseback as a target exposed to artillery. The bit of his horse's bridle was struck by shot, and cannon balls cut down branches over his head. To make surprise impossible he had doubled the vigilance of his encampment. Having taken little rest and eaten scarcely anything for several days, his staff urged him to take some rest. While his men were hastily eating the beef found so difficult to cook, he reclined under an old oak, with a coil of artillery rope for a pillow. He had rested but little from the time of taking the command. His only time for repose was after four o'clock in the morning. At four o'clock in the morning he beat three taps of the drum, the line was formed, and his men kept under arms till daylight. Laying down, he then rested till his men had taken their breakfast, and were ready to march. He had waited in vain for expected troops and supplies. His men were dispirited, and desertions had been caused by the fall of the Alamo and the massacre of Fannin's command. Consternation filled the country. The officers of Government had removed from the scene of danger to Galveston. He was without supplies or a transport in a new country. Half-armed and half-clad men were his soldiers. A powerful and cruel enemy was in his neighborhood. The picket guards of his opponent's forces exceeded in number all the men in his camp. He had difficulty in deciding on the day of battle, and he could hardly imagine its scene. But notwithstanding the terrors of suspense, and the presence of the enemy, having posted faithful guards, this man of iron will slept calmly and soundly through the night. The usual three taps of the drum (always beaten heretofore by Gen. Houston) were beaten by a stranger as the morning of the last day of Texan servitude dawned. The 700 comrades of the chieftain springing to their feet engaged in union in preparation for battle. The chieftain

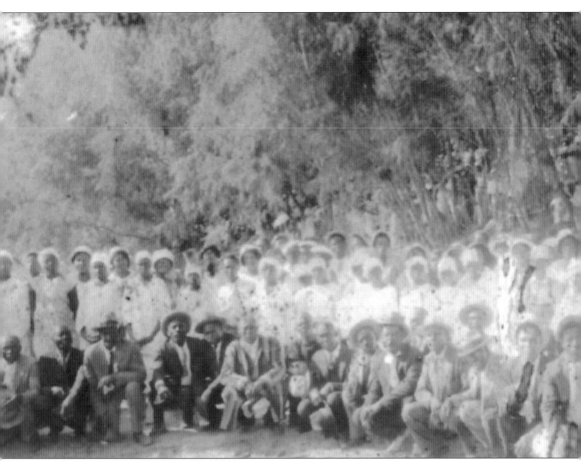

Shown are some of the well-dressed descendants of the enslaved Round Top pioneers two generations later enjoying a special ladies' or men's day, probably at a church gathering around the 1930s–1940s. In 1860, Joel Robison had 19 enslaved laborers and four slave houses in Round Top. John Robison and his son Joel's enslaved pioneers were not ignorant of John and Joel's exploits during the war for Texas Independence. While John and Joel were off engaged in their various exploits, it was their enslaved pioneers who, in their absence, had to contend with Native American attacks at home or attacks from wild animals. These unnamed pioneers were the ones who had the skill sets and labor to make it possible for John and Joel to be financially secure. Their descendants, some of whom may be shown here, are a testament to their ancestors' resilience. (Courtesy Maude Cole.)

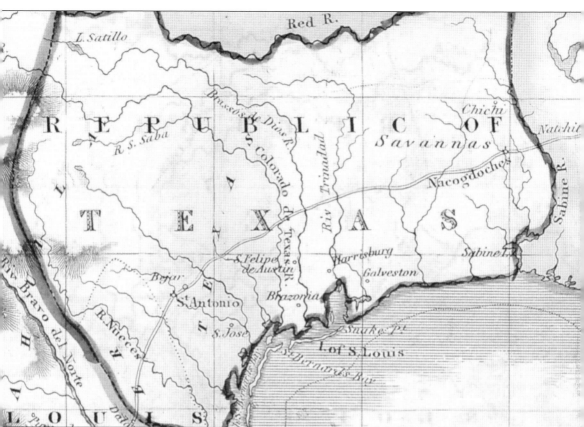

The rebellion between the settlers and Mexico lasted about seven months, from October 3, 1835, until April 21, 1836. The Republic of Texas as an independent sovereign nation in North America existed from March 2, 1836, to February 18, 1846. At 268,496 square miles, Texas is big. The only thing bigger than Texas (with the exception of Alaska) is Texas lore. Movies that depicted the Texas Revolution and the Republic of Texas lore and mini-series such as *Two for Texas*, *The Alamo*, and *Texas Rising* often did not acknowledge the existence of African American enslaved pioneers during these perilous times in history. In 1835, siding with Mexico, some 100 enslaved pioneers instigated an uprising along the Brazos River. They were inspired to do so by rumors that Mexican troops were headed their way. Anglo settlers suppressed their uprising, and although some were severely punished and hanged, a few got away and joined the Mexican army. (Courtesy Wikimedia Commons, University of Texas at Arlington Libraries Special Collections, gift of Lewis and Virginia Buttery.)

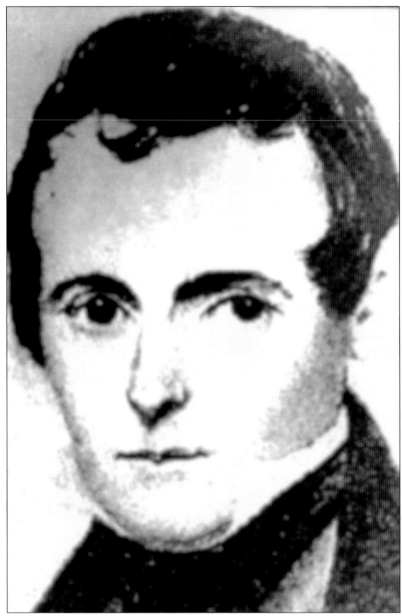

After the death of Stephen F. Austin, as a cotton-producing country, Texas was starting to boom. Texas heroes Sam Houston and Austin felt that the growth of the cotton industry in Texas could be a good bargaining chip in convincing the United States to let Texas join the Union. Consequently, plantation owner and lawyer William H. Wharton was asked to go to the nation's capital to advocate for Texas joining the Union. Wharton owned the successful cotton-producing Eagle Island Plantation as a result of his wife being given five leagues of land in Brazoria County. Because of enslaved labor, Wharton was able to build an elaborate home with imported timber, a brick sugar house, and double kettles. By 1860, when his son took over the plantation, the Whartons owned 133 enslaved people, had 700 acres of land, and were very, very rich. Wharton's trip to Washington was not successful, because free states were not keen to add another slave state to the Union. (Courtesy Wikimedia Commons, State of Texas Historical Archives.)

After the battle for Texas independence and during the years Texas spent as a republic, the number of enslaved pioneers increased exponentially in Texas. This growth made the cotton economy boom. One of the things William H. Wharton tried to use to try and convince the United States to make Texas a state was the idea that if the United States did not let Texas join the Union, Texas would become its biggest cotton-producing competition. It took 10 years for Texas to convince the United States to let it join the Union. It was finally admitted as the 28th state on December 29, 1845. (Right, courtesy Wikimedia Commons, University of Texas at Arlington Libraries Special Collections, gift of Virginia Garrett; below, courtesy Library of Congress.)

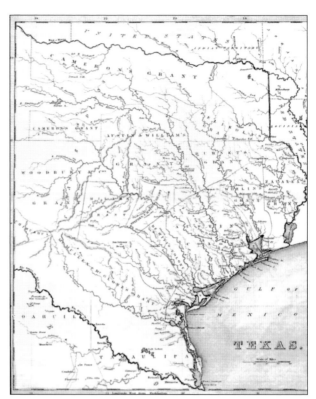

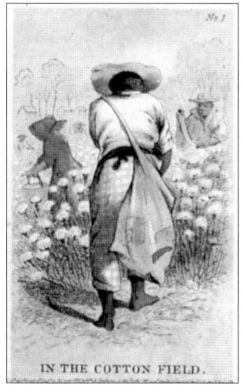

IN THE COTTON FIELD.

Slave Owners	Acreage	Number of Slaves	Slave Houses	League	Abstract Number	Abstract Date
John R. Robson	1407	39	8	W. H. Jack	A-57	March 19, 1831
W. F. Wade	1100	54	8	W. H. Jack	A-57	March 19, 1831
Hamilton Ledbetter	736	34	6	James Winn	A-114	March 31, 1831
	169			W. Towsend	A-104 FC	March 30, 1831
					A-195 WC	
	296			J. Schultz	A-280 FC	—
					A-176	
	358			Amiziah Baker	A-8	October 13, 1835
Samuel K Lewis	346	13	11	W. Towsend	A-104 FC	March 30, 1831
	772			J. Schultz	A-195 WC	
	435			J. Fletcher	A-44 FC	February 26, 1831
	64			Amiziah Baker	A-8	October 13, 1835
	30			J. Ward		
Christopher H. Taylor	4000	46		James Winn	A-114	March 31, 1831

In Round Top, Texas, five enslavers owned a total of 9,713 acres of land. Working the land were numerous unnamed enslaved laborers who built dwellings for themselves as well as the lavish plantation homes and modest farmhouses for the families who enslaved them. Included in this number of enslaved are the author's ancestors, who were enslaved by Christopher H. Taylor. All of these farms and plantations had slave quarters that were just north and east of Round Top, within a half- to three-mile radius. Slavery grew fast in Fayette and other Texas counties. This summary was taken from the Fayette County, Texas, 1860 slave census record. Of historical importance to Round Top's enslaved pioneers are the leagues of land around the James Winn league, where there were four major slave owners: John R. Robson, Hamilton Ledbetter, Samuel K. Lewis, and Christopher H. Taylor. Robson was a member of the aforementioned John and Joel Robison family.

Based on perceived age, this attractive, unidentified, well-dressed, and intelligent-looking Round Top pioneer's parents were contemporaries of people that Round Top's Joel Robison enslaved. Her parents were probably included in the 1850 and 1860 Fayette census as unnamed property. Enslaved women and men cared about their appearance. Women were very meticulous about caring for their hair. They often used household items such as kerosene or cornmeal to clean their hair. They used eggs and oil as conditioner. A head wrap was often worn to keep insects out of their hair or because their owner demanded it. Unfortunately, they had no control over their clothing. They were often issued one-piece frocks or slips made of the cheapest materials that enslavers referred to as "negro cloth." This young lady was an example of the dignity and demeanor that Round Top pioneers actually had as opposed to the stereotypical mammy and sambo images popularized in early American culture. (Courtesy Beatrice Crump-Rivers.)

#	Slave Owner	Number Of Slaves
1	Robb	1
2	EN	1
3	R. Williams	1
4	William Adams	4
5	R. I. Adams	4
6	J. R. Alexander	2
7	J W. B. Allen	2
8	E. J. Alley	3
9	William Allstone	5
10	W. B. Anderson	2
11	John B Anderson	12
13	Marcus Anderson	6
14	Sherlotta Atkerson	2
15	Eastha Atkinson	3
16	T. D. Atkison	2
17	T. Banks	40
18	James Bartesson	3
19	Luticia Baylor	2
20	Mandy J Boone	32
21	Joseph Biegel	8
22	John P. Ball	1
23	N J. Benson	5
24	James T. Bess	10
25	James Bishop	4
26	John Black	5
27	E R. Blackburn	4
28	Elishia E. Blackhill	8
29	Lucy Blackwell	10
30	Janos Blackwell	5
31	John R. Belghurn (Blackburn)	3
32	S. M. Blaxemore	1
33	Thomas L. Benton	8
34	C T M. Bery	10
35	W. Bledsoe	
36	Henry Bledsoe	10
37	John Bledsoe	7
38	Montgomery Bobb	1
39	G D. Bowen	
40	Joseph Boyle	2
41	Nancy Braddock	3
42	B W. Breeding	10
43	N B. Breeding	2
44	B L. Breeding	11
45	E W. Brenting	3
46	Eliza Bogzer	4
47	G W. Brooks	2
48	L P. Brown	45
49	J D. Brown	10
50	W. A. Brown	2
51	M D. Bruch	3
52	John Rudd	3
53	James Burke	4
54	C. C. Burns	1
55	John Butville	9
56	Absalon Byler	8
57	C. C. Byrd	1
58	E. Cane	5
59	N M. Carmecheal	1
60	D. Carmecheal	
61	Sarah Campbell	8
62	Margaret Carter	10
63	J. H. Carier	18
64	Jacob Castleman	4
65	W A. Chandler	4
66	Robert Chappell	20
67	James O. Chaney	8
68	P. D. Clair	2
69	C Clark	8
70	Margaret Clark	17
71	Peter Clawson	2
72	Franklin Clayton	2
73	Jane Clemins	9
74	E. C. Cochems	3
75	James Cochran	8
76	S. S. Cockril	10
77	O B. Coldwell	13
78	James Cole	9
79	Mary C. Collingswo	4
80	Enoch Cooksey	6
81	R. H. Coop	10
82	John Coren	1
83	Jufus Cremer	11
84	Mary Criswell	1
85	J. Y. Criswell	4
86	Leroy Criswell	1
87	J. K. Crockette	3
88	Earl Crossett	4
89	Arthur Crownover	2
90	L. F. Cunningham	2
91	D P. Deman	2
92	John W. Dancy	1
93	C. F. M. Dancy	32
94	O A. Daniels	31
95	James R. Daniels	13
96	J. E. Danson	6
97	W. P. Darby	2
98	S. Darling	2
99	W. M. Davidson	2
100	T. O. Degrafhend	22
101	J H. Dobbin	46
102	James W. Dodson	12
103	W. H. Donathan	1
104	S. H. Doxey	12
105	Joseph Orisdale	13
109	Jane S. Eans	5
110	John Ebner	1
111	J. C. Edes	5
112	A. B. Eiss	2
113	J H. Eldnge	1
114	Susan Ellis	8
115	James English	1
116	M Evans	8
117	William Faires	9
118	N. W. Faison	1
119	T. W. Farley	5
120	Joseph Ferqut	18
121	C. C. Ferill	5
122	Casper Fink	1
123	R. T. Fishburn	8
124	R. L. Fisher	7
125	D. I. Ficnell	5
126	W. H. Fitchell	3
127	Mary Fitched	3
128	C. C. Fitzgent	11
129	Samuel Fitzge	3
130	William Fitzge	1
131	C. P. Flach	2
132	C. G. Forshey	3
133	A. France	1
134	N. Franklin	3
135	D. Y. Fulton	1
136	D. G. Fulton	11
137	Joseph Gage	8
138	J. C. Gage	1
139	James C. Gant	
140	A. R. Gales/Ga	44
141	John Gaudng	18
142	R. R. Gay	34
143	J L. Gay	3
144	James L. Gay	34
145	Jorden Gay	8
146	John J. Gossle	8
147	Rm > Giles	4
148	William T Grid	22
149	J. W. Glass	7
150	James Glass	10
151	Fletcher Glass	1
152	Wesley Gass	2
153	William Gothe	1
154	W. W. Goring	7
155	Andrew Graha	1
156	A. H. Gray	1
157	S. Green	5
158	W. H. A. Green	1
159	Lee Greene	9
160	U. Gregory	7
163	B H. Grover	6
164	Isaac Hamilton	2
165	L. L. Haney	18
166	A. H. Hanna	27
167	S. J. Harington	37
168	S. J. Harrall	8
169	Perry Harmsonb	5
170	L. B. Harrison	13
171	John N. Hart	11
172	L. S. Hart	1
173	John Haynie	4
174	James Haynie	3
175	Francis Heiler	4
176	Peter Hencl	1
177	Thomas J Henderson	36
178	George Herdar	2
179	G. F. Herreld	2
180	Mitt Hel	6
181	William H. Hilleman	7
182	Rod Hines	1
183	Edward Hinkle	1
184	George T. Hobertn	16
185	John M Hedge	8
186	Holtyrook	1
187	J. D. Holman	4
188	F. B. Hood	3
189	Elizabeth Hopson	11
190	Thomas P. Hubberd	4
191	Jno A. Huber	9
192	E. P. Dudson	1
193	William Hudson	
194	Henry Huff	4
195	I. V. Huff	1
196	William Hunt	19
197	John Hey	1
198	John Ingram	12
199	John G. Izard	1
200	John Jachary	1
201	J. Jackson	
202	R. B. Jarmon	87
203	W. R. Jarmon	13
204	Stephen Jarmon	41
205	Celeba Joiner	
206	N. C. Joiner	1
207	J. H. Jones	2
208	A. R. Jones	10
209	Williams Jones	8
210	D. P. Justice	1
211	F M. Karnes	
212	J. H. Kerby	4
213	Simon Kirk	8
214	H. R. A. Kliner	1
218	James Lane	6
219	Hamilton Ledk	
220	C H. Lee	
221	R H. Lewis	
222	C. D. Lewis	
223	S. W. Ligon	
224	W W. Ligon	
225	Rerenhappah	
226	W. B. S. Ligon	
227	L. Lindsey	
228	Upton Loman	
229	Samuel Loren	
230	James Lowd	
231	James Lowell	
232	Coline Lucas	
233	Mary Lyons	
234	Luther Mahen	
235	A. P. Marier	
236	Edward Manton	
237	James K. Mart	
238	Tobocra Mart	
239	Joseph X. Nax	
240	George McscoF	
241	W. H. Matthew	
242	Joseph P. May	
243	P Y. McSsfar	
244	E. McAshan	
245	S. A. McAsfar	
246	Alfred A. McCl	
247	S A. Mcoilen	
248	A. H. McClism	
249	James H. McC	
250	A. Z. McCoy	
251	Alexander Mc	
252	Arthur McDow	
253	J. R. Mcdow	
254	I. B. McRarlin	
255	J. M. McGahel	
256	Samuel R. Mc	
257	O. A. McGk-n	
258	S. D. McGloul	
259	Sam McGowa	
260	W. C. McGow	
261	Neil M. Mcha	
262	Henry McCroy	
263	William Mene	
264	Quin M Mene	
265	John Meyer	
266	James W. Mel	
267	T B. Mitchell	
268	Mary Moll	
269	Henry Moore	

As this chart shows, there was a sizable enslaved pioneer presence in Fayette County during the Civil War years. This 1860 chart shows a listing of 451 slaveholders and 3,722 enslaved pioneers. Summaries such as these do not list enslaved persons by name. They only list them by color, age, and gender. This is why the majority of the names, faces, and deeds of the early Round Top pioneers will likely never be known.

1860 Fayette Overseers

John R Cook	A J Cron	J W Lane	B F Moore
Isern Clements	John S Giles	G W Scallon	William Faires
Henry Williams	S W Dancy	William W Staple	

Numerous Fayette and Round Top enslaved pioneers on plantations had to contend with overseers. An overseer's job was to produce a profitable crop. It did not matter the weather conditions, the laborers' age or gender, or if the laborers were ill or tired; it was the overseer's job to get enslaved pioneers to labor as long and as hard as needed to create profits for their owners. Some plantations also had African American drivers who were expected to keep order and discipline in the field per the overseer's instructions. The white-headed Round Top grandfather or father shown sitting with his family no doubt experienced the days of overseers. His meticulously dressed and composed family is proof that newly freed men valued the family unit and that, in appearance, they did not fit the stereotypical media images of the era. (Below, courtesy Beatrice Crump-Rivers.)

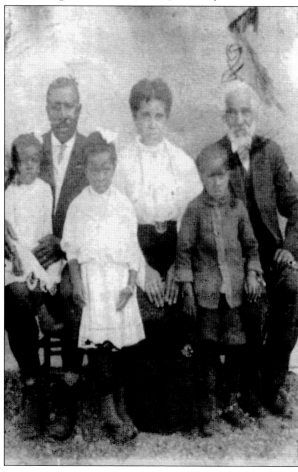

Articles of agreement made and entered into this day by and between Martha E. Ligon, who acts both for herself and as Guardian of the property of Nancy Ligon minor heir of Wm H. Ligon deceased of the first part and Anderson I. Ross of the 2nd part,

1st - Said parties hereby agree to go into partnership in farming upon a place in said County about 8 miles north of LaGrange, and the same place known as the James M. Eanes farm, containing 350 acres in the whole tract more or le And the same farm deeded by said Eanes to S.M. McAshan and George R. Seay(?) and by them sold to Wm. H. Ligon;

2nd - Said Martha E. Ligon hereby agrees with said Ross to give him the exclusive management and control of said farm for five years from the first day of January next, but with the privilege to said Ross of leaving or giving the same up to her with all the negroes and other matters she may furnish at the end of any one of the five years.

3rd - She further agrees to furnish said Ross for the same time the following negroes, viz Coleman, Mary and Louise;

4th - Said Ross on his part agrees to furnish the following negroes viz, Burrill, Edy and Matilda, fo so long a time as he shall stay on said farm;

5th - Said Ligon also agrees to furnish another negro name Ell (male), and said Ross binds himself to pay unto her for the use of said boy on said farm the sum of $20 per year for every year he may remain on said farm;

6th - Said Ross also agrees to take charge of all of said negroes, to use one for a cook on the farm and the others to work thereon, and to cultivate the farm in a workmanlike manner, and to take care of, manage and control it as a prudent man would his own;

7th - It is further agreed by the parties that each one of them is to furnish and pay an equal part of the expenses of the farm for tools provisions and all necessary expenses;

8th - It is further agreed that each shall furnish an equal quantity of team necessary to carry on the farm;

9th - It is further agreed that said Ross shall purchase tools, provisions and such other matters as may be necessary on the farm to be paid for out of the proceeds of the crops;

10th - It is further agreed that said Ross may take in more land if he sees proper, and also make such improvements as he thinks needs, but without cost to said Ligon;

This 1858 Fayette County deed offers a look into antebellum life and what it was like for the enslaved. Martha Ligon, after the death of her husband, was unable to manage the pioneers she enslaved or the 350 acres of land she owned. She went into partnership with Anderson I. Ross to manage her farm for five years. A few early enslaved pioneers listed on the deed are Coleman, Mary, Louise, Burrell, Edy, Matilda, and Elle. This deed illustrates how enslaved pioneers were often separated from their family members and that their labor was loaned out to address their owner's debts. Ligon used her enslaved labor to cook family meals, work the cotton and corn fields, grow food for the family, take care of 50 heads of cattle, milk and butcher cows, and lastly, sew clothing for the enslaved, both adults and children. Of note is that Ross specifies in the agreement that his White family be given free meat and cornbread. This indicates that those enslaved were not entitled to the same provisions. (Courtesy Fayette County, Texas Clerk Office.)

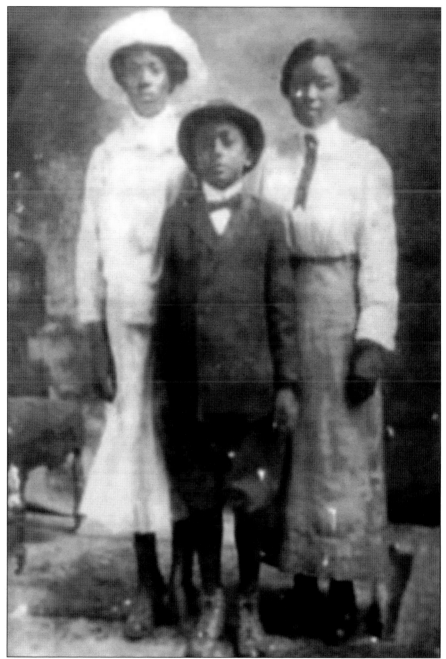

Prior to and during the Civil War, Round Top pioneers were considered property, so no matter how skilled, how intelligent, how clever, how industrious, how heroic, how handsome, or how beautiful they may have been, none of that was ever recorded. If an enslaved person invented anything, such as the enslaved Tennessean Nathan Green, who invented Jack Daniels whiskey, their owner would consider that person's invention their proprietary property, and the owner, not the enslaved, would get the credit or financial benefit and, if warranted, the patent as well. Shown is a very well-dressed, attractive-looking, and composed unidentified Round Top family whose parents and grandparents may have been enslaved in the Round Top area.

Unidentified Confederate Soldier

For decades, the North and South were at odds over things like cultural differences, states' rights, economic practices, and most importantly, slavery. As a civil war became more of a reality, enslaved Round Top pioneers began secretly rejoicing and hoping for their freedom. Meanwhile, their owners, such as the impressionable Fayette County teenager William H. Thomas, were running off to Austin to sign up to fight for the Confederacy, possibly in the name of Southern honor or states' rights. The enslaved, however, probably had the opinion that he was going off to fight to defend the right of his father, Fayette County's Nathan Thomas, to be an enslaver. Nathan Thomas at the time owned 18 enslaved pioneers ranging in age from two years old to sixty years old. (Courtesy Library of Congress.)

County†	—Journal*—		—MSS Election Returns†—			County†	—Journal*—		—MSS Election Returns†		
	For	Against	For	Against	Other		For	Against	For	Against	Other
Anderson	870	15	870	15		Fort Bend	486	none	486	000	
Angelina	139	184	139	184		Freestone	585	1	585	1	
Atascosa	145	91	145	91		Galveston	765	33	765	33	
Austin	825	212	825	212		Gillespie	16	398	16	398	
Bandera	33	32	33	32		Goliad	291	25	291	25	+1
Bastrop	335	352	335	352		Gonzales	802	80	802	80	
Bee	139	16	139	16		Grayson	463	901	461	901	
Bell	495	198	496	198		Grimes	907	9	907	9	+1
Bexar	827	709	827	709		Guadalupe	314	22	314	22	
Blanco	86	170	108	170		Hamilton	86	1	86	1	
Bosque	233	81	223	79		Hardin	167	62	167	62	
Bowie	268	15	268	15		Harris	1084	144	1128	163	
Brazoria	527	2	527	2		Harrison	886	44	866	44	
Brazos	215	44	215	44		Hays	166	115	166	115	-1
Brown	75	none	16			Henderson	400	49	397	48	
Burleson	422	84	422	84		Hidalgo	62	10	62	10	
Burnet	159	248	157	248		Hill	376	63	376	63	
Caldwell	434	188	434	188		Hopkins	697	315	697	315	-8
Calhoun	276	16	276	16		Houston	552	38	552	38	
Cameron	600	37	600	37		Hunt	416	339	416	339	
Cass	423	32	423	32		Jack	14	76	14	76	
Chambers	78	6	109	26	+5	Jackson	147	77	147	77	
Cherokee	1106	38	1106	38		Jasper	318	25	318	25	
Collin	405	948	485	948		Jefferson	256	15	256	15	
Colorado	584	330	584	330		Johnson	531	31	531	31	
Comal	239	86	239	86		Karnes	153	1	153	1	
Comanche	86	4	86	4		Kaufman	461	155	461	155	
Cooke	137	221	137	221		Kerr	76	57	76	57	
Coryell	293	55	293	55		Lamar	553	663	553	663	
Dallas	741	237	741	237		Lampasas	85	75	85	75	
Denton	331	256	331	256		Lavaca	592	36	592	36	
De Witt	472	49	472	49		Leon	534	82	534	82	
Ellis	527	172	527	172		Liberty	422	10	422	10	
El Paso	871	2	871	2		Limestone	525	9	525	9	
Erath	179	16	185	27		Live Oak	141	9	141	9	
Falls	215	82	215	82		Llano	134	72	150	72	
Fannin	471	656	471	656		McLennan	586	191	586	191	
Fayette	580	626	580	626		Madison	213	10	213	10	

Not everyone was as eager to wage a civil war as were men like enslaver Thomas or overseer Scallon. On February 23, 1861, a county-by-county referendum vote was held. Not every resident in Texas wanted to see the Union dismantled. Fayette County joined Bastrop, Travis, Williams, and 14 other counties in casting a vote to stay in the Union. When called on to vote, 580 Fayette County residents voted to secede while 626 voted to stay in the Union. Despite the majority opposition to succession in Fayette County, by September 1861, eager young Fayette County men were joining up to fight for the Confederacy. In Austin, Texas, on February 1, 1863, a secession convention approved an ordinance to withdraw Texas from the United States of America. (Courtesy *East Texas Historical Journal*.)

The German presence in Fayette County was significant during the Civil War. German immigrants began arriving in Texas in the 1840s and 1850s due to the economic, social, and political upheaval in Germany. In 1842, there was actually an attempt to create a colonial German settlement in Fayette County. Twenty-one German noblemen met together at the castle of the German Duke of Nassau to organize the Adelsverein. The Adelsverein bought land in Fayette County to establish a plantation. They then purchased 25 enslaved Fayette pioneers to work the plantation. Their colonization attempt ended in 1853 due to insurmountable debt. Of note is that German and Bohemian immigrants were among the Fayette County residents who opposed leaving the Union. When the Confederacy passed the 1862 Conscription Law, the Fayette Germans vocally opposed it. Shown is Prince Carl of Solms-Braunfels, an Adelsverein establishment leader. (Courtesy Wikimedia Commons, Aldina de Zavala.)

Two

THE TAYLOR AND LEDBETTER PLANTATIONS

Christopher H. Taylor and William Hamilton Ledbetter were two Round Top plantation owners who have histories tied to the founding of Round Top and Ledbetter, Texas. They also have a history that is tied directly to the African American Round Top community. They were both large plantation owners whose prosperity can be directly tied to slavery. Those ties, for various reasons, have lasted through the generations in Round Top's African American community. To understand these two men is to understand the role of the planter during the antebellum days. Plantations were early settlements that had their origins in colonial expansion. In the United States, these settlements were run primarily by Anglo-American men. The daily life of these settlements revolved around agriculture. They also revolved around forced labor. Plantation owners in America generally came into the possession of their lands due to the forced removal of the American indigenous people. Plantations were an early form of capitalism because their very existence depended upon growing a cash crop for sale on the market—a market that was international in nature. Cotton and sugar were the most profitable Southern planters' crops. Large plantation owners, because of their wealth, were the aristocrats of the South.

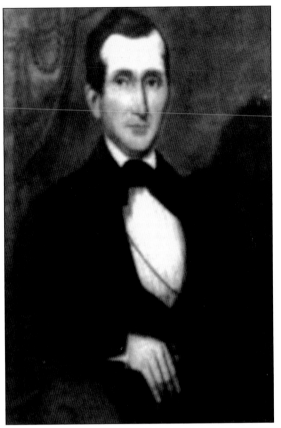

Christopher H. Taylor left a historical footprint that most Americans do not talk about. He has a backstory similar to the famed Thomas Jefferson and Sally Hemings story. Tennessean Taylor, born in 1812, migrated to Texas during its early days in the 1830s and 1840s. He became a successful merchant and amassed a 4,000-acre plantation that was located along Highway 237 and Jaster Road and extended north of Round Top's town hall, where the local bank currently sits. The current historic Round Top Festival Institute sits on Taylor's land. In 1860, he owned 42 enslaved pioneers aged 65 years to 6 months and 8 slave dwellings. The author's ancestors were among Taylor's enslaved pioneers. The author's grandfather has ancestral memories of him being known during his time as "Kit" or "Kid" Taylor. Shown is Taylor's cousin, also named Christopher H. Taylor. (Both, courtesy Greene County Alabama Museum Archives.)

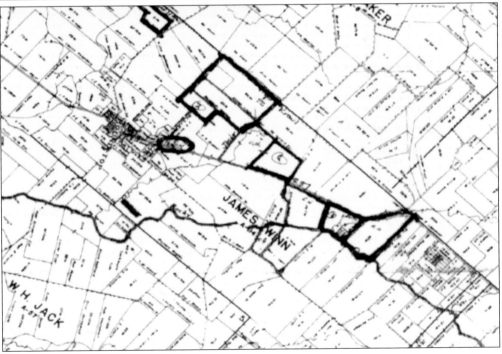

Dearest Grand daughter

Your beautiful lines written with those precious little fingers dated 1 Feby and mailed the same day did not reach me 1 crib the day before yesterday owing (I presume) to a failure in the mail between Houston and Round Top. Tho for that My Dear it is none the less endearing, and affording me a most unspeakable pleasure to know that I still live in the memory of so dear and affectionate a Grand Child. The pleasing account you gave me of your Ma, yourself and your School was indeed a very exceptable part of your letter.

You speak of Miss Wooly which name sounds quite familiar in connection with that of Viena yet I do not clearly recollect the family and their whereabouts in Viena. You tell me your Ma has chosen her to be your Companion at School and at home which is really thoughtful and kind of your dear Mamma, for which I feel assured that you both will love and obey her as you have always done yourself my dear dear Cherokee. I already imagine that I see you and your little friend taking a walk after the close of School in the evening. You must not let her leave you dear I come, I will then entertain you during your playful hours as I use to do your Aunt Helen and Cousin with some of my old storys newly dressed.

I am now my dear numbering the days the days (as they pass) of the last month that I shall remain in Texas unless your Uncle would assure me of his company home by my staying a few weeks longer, which he now says he cannot do, but is willing that I should go in April which he thinks the most favourable time to cross the Gulf. I hope to meet with some acquaintances going over, as there is scarcely a stage passes without passengers bound for Alabama.

Please say to your dear Ma that her esteemed favour of Jany past was duly received, in which she complained of having no time to write. I therefore declined troubling her immediately but will write her before I leave here. Did you know My Dear that you had another dear little Cosen in Mobile, and her name is Elizabeth. I presume your Uncle John has written to your Ma all about it. Say to your Aunt Eliza that her dear boys John and Bob are in fine health and spirits, and speak of visiting her December next, with a hope that she will return with them to Texas.

I would now dear give you a description of your Uncles beautiful place but that it would occupy my whole sheat to give it justice. So I must wait I see you and tell you all personally. Your Cousin John begs to be remembered to you with grateful thanks for his small part of your letter to me. Nothing could have been more pleasing to him than the few words you sent to him. Say to your dear Aunt X that I was both surprised and well pleased to meet with Lawyer Baylor formerly of Tuscaloosa, who is now our Baptist Preacher and says he has done a great deal of good in Texas. He is much beloved in our neighborhood both as a citizen and a minister of the Gospel. We have preaching near us every Sabbath, and if she was only here I know I should go to Church oftener than I do, as I have a very fine horse and buggy but I am often for want of such company as I like tho I have many neighbors.

Your Cousin John again My Dear begs the favour, should you see your Cousin P.V. give her a pinch and say to her when did you write to Cousin John in Texas. Altho My dear I have been for several honors I still feel disposed to go to the bottom of my sheet, but my pen has already run so fast that I fear you will wish you had never put it in motion, but you must recollect my ever dear Child that you and your pore old Grand has not even met by letter in a long time.

As I sit by the window I this moment see your Uncle [? Name] Cousin Kit and our Mexican horse rider pass by with sixty cows and calves to be pened for a I and they have gone again for more. I often wish you could see the Sheep and Goats come up at night. How beautiful to this eye, such a large number. And that you could see our Mexican throw a rope over a wild horses head and then get up and ride him. Such jumping and kicking you never seen, but the riders never throwed of. These Mexicans are singular folk, and so funny.

Now My Dear I will close my letter for I know your patience will be well I and thread bare before she gets through with what I have written. Observe minutely (My Dear) all deficiencys in my letter but do not expose it to every eye. Pardom me that last request is unnecessary. If this however does no more than amuse you I shall be pleased.

I will only add a Mothers love to your dear Pappa your dear Ma your Aunt Eliza Aunt X Kay and all the dear Children.

Your Ever affectionate Grand Mother
Elizabeth Taylor

By 1850, at the age of 39, Kid Taylor had comfortably settled in Round Top. He married Nancy Dew in Eutaw, Greene County, Alabama, on August 2, 1858. Members of his household at that time were his mother, Elizabeth Taylor, age 60, born in Tennessee; John Hill, age 19, born in Alabama; C. Hill, age 14, born in Alabama; A. Lunciford, age 21, born in North Carolina; and Harvey Alexander Adams, age 38, born in Rhode Island. His mother, Elizabeth, in a letter she wrote to her granddaughter, gives insight into the daily lives of the Taylor family. They seem to have had a very comfortable lifestyle on the James Winn league of land reminiscent of Scarlett O'Hara's fictional family in the movie *Gone with the Wind*. In the letter, she describes how she is enjoying her visit to Texas and wishes to stay a while longer. However, her son advises against staying any longer and tells her it is better to cross the Gulf of Mexico in April. (Courtesy Patricia Hansen and Round Top Historical Society.)

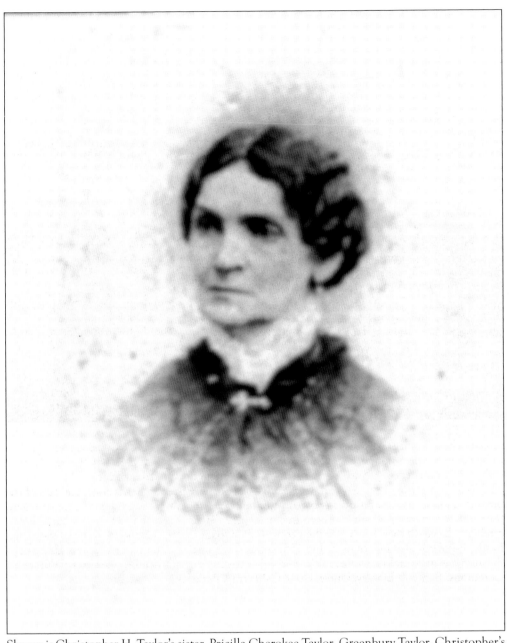

Shown is Christopher H. Taylor's sister, Pricilla Cherokee Taylor. Greenbury Taylor, Christopher's father, was born in 1746 and had two children, born in 1812. One child was born in Alabama, and the other child was born in Tennessee. Pricilla's middle name may be indicative of her heritage. (Courtesy Greene County Alabama Museum Archives.)

Also in Elizabeth's letter, she describes a Mexican cowboy (vaquero) employed by them. She recounts how, as she sits by the window, she sees him and her son ride by with 60 cows and calves to be penned. She is impressed with his roping skills and his ability to tame wild horses. A lot of early Anglo ranchers depended on vaqueros to teach them how to deal with the wild horses and wild longhorn cattle of the day. The longhorn cattle, having been in Texas since the days of the Spanish conquistadores, for over two centuries had been roaming wild in Texas. Unfortunately, the vaqueros, many of whom had been in Texas since the early days of the Mexican hacendados, rarely get the credit they deserve for their contribution to taming the longhorns and wild mustangs. Lastly, Elizabeth also mentions in her 1851 letter the name "Kit,"—a name that was also passed down in the ancestral memories of the author's African American family. (Courtesy Wikimedia Commons, Bancroft Library, University of California, Berkeley.)

As mentioned earlier in this history, the author has a Mexican settler on his family tree who lived in America during the time of Elizabeth Taylor's letter. Ben Garcia was the father of Frank Garcia, shown earlier. Frank Garcia was the father of Roy Garcia, shown above, who was the author's uncle by marriage. Roy B. Garcia was born on August 8, 1908, in Guadalupe County, Texas, in Sequin, named after Juan Sequin, who fought in the Texas Revolution. On October 12, 1930, Roy married Bessie Katherine Collins. She was born in 1912 in Lee County. Roy's ancestors probably came to Texas as vaqueros. The Garcia family compound still exists today in the Freedom Colony of Belmont, which is located on the east side of Highway 80 and the Guadalupe River, just south of Luling, Texas.

Fayette Taylor was born in Lee County to Wesley Taylor and Martha Jane Crenshaw-Taylor in February 1876. As part of America's "one-drop" legacy, Fayette is listed in the Lee County 1900 census as Black. There are some parts of the Christopher H. Taylor story that are uncomfortable parts of American history. These are history stories seldom admitted to or told. Most slave schedules that belonged to planters had mulattos listed on them. Encounters between enslaved women and their enslavers were never consensual, because enslaved women, as property, had no control over their daily lives. There are numerous antebellum stories of enslavers falling in love with the women they enslaved. Christopher H. Taylor produced several mixed-race offspring, and he also fell in love with the mother of one of them. (Courtesy Lena Kathryn Smith.)

The Alabama 1880 Census showed that Taylor at age 68 was living in Eutaw with his wife, Nancy, aged 55. Also living with him was his brother-in-law Dew, aged 54, and an overseer from South Carolina named Joseph Barris. The 1880 census lists the letter M next to the names of several members of Taylor's household. M stands for mulatto, which was a historical term used to describe mixed-race children conceived by enslaved women often due to forced conception. Listed as M in Taylor's household were a Florida cook named James and three servants. Also listed was a servant named Sarah Ann Taylor and her five children, aged one month old to nine years. It was an open secret that Sarah Ann was Taylor's mistress and that the children were Taylor's offspring. (Courtesy Ancestry.com.)

[Handwritten text, partially legible:]

laid Harris for their Trouble — and if I don't
have the money, then the Administrator is to
the best notes on property to raise the mon-
ey on — as some money will be needed
the time of Burial

 C. H. Taylor

 Page 2.

Article 3 I give to a molatto woman Sarah Ann Taylor
who is Liveing with us and my wifes [the]
Servant and has been for many years and
for her faithful and undivided attention to
my wife I give to her, my Choctaw Planta-
tion known as Choctaw Bluff lying about Four
miles from Eutaw containing about Thirteen Hun-
dred & Ninty six 65/100 Hundred acres of land about
half of it on the East side of the Warrior river
and the other part on the West side and join

Taylor was so wealthy that he owned several plantations in both Alabama and Texas. To financially protect Sarah Ann Taylor, on April 25, 1890, he drew up and recorded a will two years before his death. Interestingly, in his six-page Alabama will, he wills not one but two of his plantations to Sarah Ann and her children. One of the plantations bordered a plantation his wife, Nancy Dew, owned. Page 2, article 3, states, "I give to a molatto woman Sarah Ann Taylor who is living with us and my wife's lady servant and has been for many years and for her faithful and undivided attention to my wife I give to her, my Choctaw Plantation known as Choctaw Bluff . . . containing about thirteen hundred & sixty six 65/100 acres of land . . . joining my wife's Pickens Plantation." (Courtesy Ancestry.com)

John W. Taylor died on February 10, 1892. For the sake of brevity, everything that happened after Taylor's death cannot be listed. However, the ensuing battle over Taylor's will was like an episode from a soap opera. As was usual in cases like this one involving African Americans, if the enslaver attempted to free any of his enslaved people or to provide financially for any of his enslaved, or previously enslaved, people after his death, his will was always contested by relatives. Judges in most cases sided with the deceased White family over the deceased Black family. This is what happened when Taylor tried to provide for his mulatto mistress and her children in his will. Page 3 states, "Give this above named Choctaw land to said Sarah Ann Taylor her life time to be managed and controlled by her . . . and then to her children. . . . I also give said Sarah Ann Taylor Town good about $75 dollars, horses or mules and Town good milk cows and calves." (Courtesy Ancestry.com.)

half of all my Lands in Texas and Alabama
then life time (Except what I give to others in
this my Will—

2 I Also give to all of my Nephews and Neices
One Thousand dollars each in Cash after it is made
out of my Eestate and as Robert I Hill my Nephew
has treated me differently from what I wished
I leave him him out of the (1.000.) One thousand
dollars Gift in this article 12, and give him only
three Hundred dollars — this my will look some
what Blotted but can certainly be made out
Clearly,

3 I Also give to Sarah Ann Taylor my, wifes Lody Ser-
vant the following Lands in adition to the Lands
here given to her in Article 3. in this my Will
The Gandy Plantation Lying about five miles from
Clinton and on the Road to Union and about
thre miles from Union

Page 7 states, "I also give to my dear wife Nancy D. Taylor one full half of all my lands in Texas
and Alabama. . . . I also give to Sarah Ann Taylor my wife's lady servant the following lands in
addition to the lands here given to her in article 3 in this will The Gandy Plantation." Taylor had
a stepdaughter named Eula who was livid that she was not provided for anywhere in Taylor's will.
Eula's mother, Annie, who was another of John's wives, had a daughter with John named Grace
who was Eula's sister. Eula was suspected of being the daughter that resulted from Annie having
lived an "adulterous life with a man named Cedars or Seiders" and, after having lived with him
for only two weeks, then left with him to go to Austin. Consequently, after Eula's birth, Taylor
never claimed her as his own daughter. Angry, Eula, with the help of Taylor's brother-in-law (shown
in the 1880 census) John Dew, went to court to address her perceived wrong after Taylor's death.
(Courtesy Ancestry.com.)

Taylor reportedly once told his lawyer, "He'd rather give the money to the blackest negro before giving anything to her [Eula]!" In the end, the daughter Grace he had with Annie was awarded a quarter of the land willed to "the Negress," and his stepdaughter Eula was awarded nothing. The judge made the sisters Grace and Eula pay all court costs. However, one of Taylor's descendants, Patricia Hanson, noted in a February 3, 2012, letter to the author that Sarah Ann and her children "never received the inheritance." Shown is Addie Taylor, sister to Fayette Taylor. She was born on October 12, 1887, near Ledbetter, Texas. She is buried in the Copperas Cemetery in the Doaks Spring Freedom Colony in Lee County, Texas, just south of Old Dime Box, Texas. The same as Fayette, she is listed as Black in the 1900 census. (Courtesy Lean Kathryn Smith.)

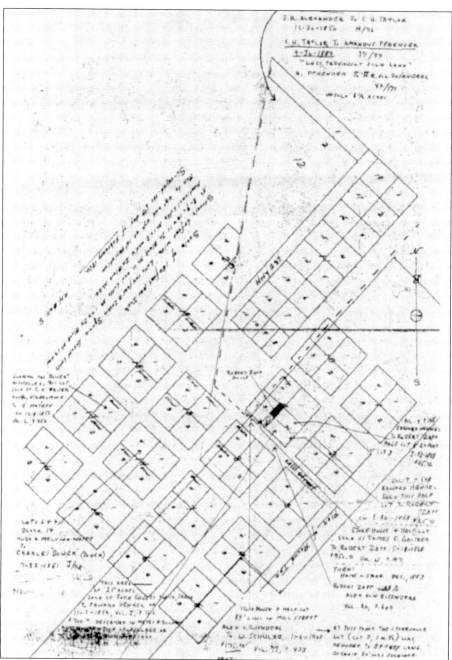

Although Christopher H. Taylor, in his lifetime, was a very successful entrepreneur, his fortunes, as with many other Southern planters, started to dwindle in Texas after the Civil War ended. The losses he incurred in Texas from the effects of the war forced him to abandon his Texas enterprises and move back to Eutaw, Alabama, where he still had significant holdings. He sold most of his holdings, including land, livestock, barns, and equipment, to John R. Alexander, Mary Alexander, Myers F. and Patsy Jones, Sarah and McHenry Winburn, Amandus Pfaender, and William Graf. As mentioned earlier, he died in Eutaw. Shown is a block of Round Top property that was once part of Taylor's vast plantation. (Courtesy Round Top Historical Society and Herb L. Diers.)

The Connersville Primitive Baptist Church Cemetery is one of the oldest Black cemeteries in Round Top that has ties to Round Top's slavery era. It exists because of the Ledbetter family. William Hamilton Ledbetter and Christopher H. Taylor were neighbors in 1850. They both owned large plantations in the Round Top area, and their lives, in different ways, intersected with Round Top enslaved pioneers. There were three generations of men named William Hamilton Ledbetter. One was born in 1808, another in 1834, and the third generation was born in 1862. The town of Ledbetter, Texas, is named after the Ledbetters.

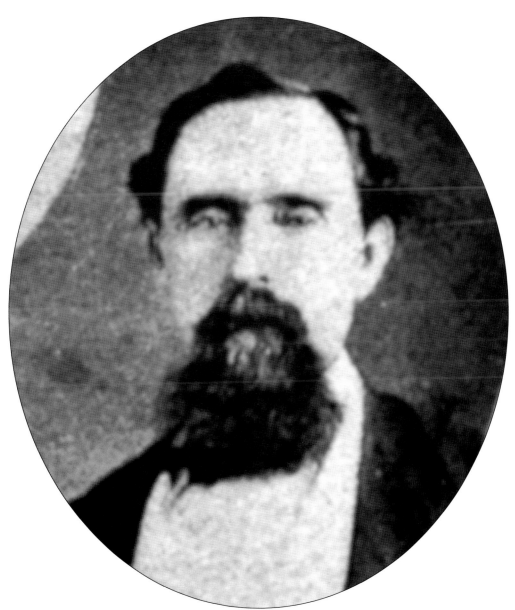

William Hamilton Ledbetter Sr. was born on April 14, 1808, in North Carolina. In 1829, he married Jane Amanda Peacock. In about 1839, the William Hamilton Ledbetter family relocated from Perry, Tennessee, to the James Winn league in northern Fayette County. Like the Taylor family, the Ledbetters came to Texas with the intent of establishing a profitable plantation. Prior to their move, records indicate that they owned 11 enslaved pioneers. After migrating to the Fayette County area, Ledbetter managed to amass 1,559 acres that stretched across four leagues of land. He owned 736 acres in the James Winn league, 169 acres in the William Townsend league, 296 acres in the Schultz league, and 358 acres in the Amaziah Baker league. To make his lands profitable, he needed enslaved laborers. By 1850, Hamilton owned 11 enslaved pioneers ranging in age from 50 to 17. By 1860, his enslaved pioneers had built six dwellings, and their numbers had grown to 34. (Courtesy Legislative Reference Library of Texas.)

Like the Taylor enslaved pioneers, Ledbetter's enslaved pioneers, many of whom are buried on the Ledbetter land, worked hard building these men's fortunes. Shown is the headstone of a Round Top pioneer buried on Ledbetter land who was born into slavery in 1843. To successfully build Ledbetter's fortune, the enslaved pioneers had to chop down trees and burn brush on the land in order to clear it for cultivation. They built roads and housing for Ledbetter. They tended to and managed his livestock and poultry. They grew and cooked his food. These laborers created enough financial stability for the Ledbetters that it made it possible for William Hamilton Ledbetter II and III to create a life for themselves outside of having to rely on manual labor farming.

CADET RECORD. Cadet-Mid. *W. H. Ledbetter*

I certify, on honor, that the above entries are correct. *William Hamilton Ledbetter*, Cadet-Midshipman

CONDUCT RECORD.

The most famous of the three generations of the Ledbetters was William Hamilton Ledbetter II, born in 1834. Ledbetter was a successful lawyer who served in both the Texas House from 1864 to 1866 and in the Texas Senate from 1876 to 1881. He also fought in the Civil War with the 16th Confederate Texas Infantry. His son William Hamilton Ledbetter III also became a lawyer and went on to attend the Naval Academy at Annapolis where, in 1879, he served as a midshipman. Shown is his Navy cadet record. William III, as a youth, was quite unruly. In the month of October, as shown on his cadet record, he was written up for various Navy infractions almost daily. (Courtesy Ancestry.com.)

The Connersville Primitive Baptist Church Cemetery that fronts on FM 1457 is located just inside the west property line of land once owned by the William Hamilton Ledbetter family. The most visible graves are those of the descendants of the original enslaved Round Top pioneers. The original pioneers, due to the era in which they lived, were likely buried there without any headstone recognition. To date, no other Black cemetery has been located within a three-mile radius of this area.

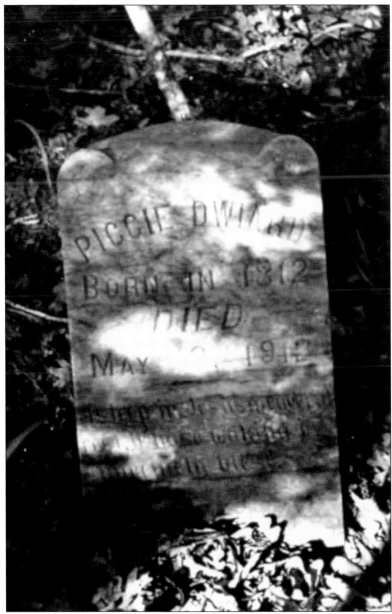

One of the earliest grave markers in the cemetery belongs to a woman named Piggie Diward, noted as being born in 1812, and who died in 1912 at 100 years of age. Her inscription reads, "Asleep in Jesus peaceful rest whose waking is supremely blest." Other descendants buried there are the families with the surnames of Leonard, McCoy, Sampson, Shelby, Wade, Craft, Rivers, Williams, Townsend, Vincent, Lewis, Goins, Knotts, Boyd, Ferguson, Jefferson, Collins, and Cole. Two African American churches used the Connersville Cemetery as their burial ground. Concord Missionary Baptist Church had to share the cemetery with Connersville Primitive Baptist Church to bury its deceased members. Although the Connersville Church and Cemetery deed is dated 1893, reportedly the Town of Round Top would not allow African Americans to be buried next to the Concord Missionary Baptist Church. As a result, it is thought that the Connersville Cemetery is likely much older than 1893.

The Connersville Primitive Baptist Church Cemetery is of such historical importance to the history of Round Top, Texas, that for the last several years, a few Round Top current and former residents, both African American and White, including the author, have been working hard to get a historical marker put in place at the entrance to the site to recognize these pioneers and their many sacrifices that helped found the community. In 2021, the historical marker was put in place. Shown at the unveiling are, from left to right, presiding elder Raymond Bryant; Bobbie Nash, chair, Fayette County Historical Commission; Luke Sternadel, Fayette County; Joe Weber, county judge, Fayette County; David L. Collins, board member, Round Top Area Historical Society; and Neale Rabensburg, president of the Round Top Area Historical Society. (Courtesy Randy Melton.)

Three

FREEDOM COLONIES

As the Civil War years raged on, enslaved Texas pioneers waited anxiously for news of the outcome. That news, for them, came on June 19, 1865, in Galveston, Texas, when Union major general Gordon Granger officially informed all enslaved pioneers in Texas that they were now free. Today, that historic day is an official American holiday known as Juneteenth. When the war ended, although some of the enslaved pioneers chose to stay where they lived, many of them abandoned the plantations, large farms, and town centers where they had once lived and labored. If they could not find shelter with another formerly enslaved family who had a home, they made do in the woods, slowly building their own communities log by log. Post–Civil War, there were 477 independent Black Freedom Colony communities in existence in Texas between the years of 1865 and 1900. Eighty-one of those Freedom Colonies with the earliest known existence appeared on the northern line of the Oklahoma-Texas border and in east Texas paralleling the Louisiana-Texas border, south as far as Victoria, Texas, and west as far as Fort Worth and San Antonio, Texas. One colony appeared as far west as Bracketville, Texas. The counties with the largest number of Freedom Colonies were Smith, Cherokee, Houston, Marion, and Lee Counties. Lee County has perhaps the most recognized Freedom Colonies of all the counties, with colonies such as Antioch, Betts, Chappel, Doak Springs, Dockery, Globe Hill, Jones Colony, Leo (Field's Spur, Leo Switch), Nunnsville, Pin Oak, and Sweet Home (Liberty Valley). Also readily recognized are Cozy Corner and the Armstrong Colony in Fayette County. Once the formerly enslaved pioneers began leaving their former owners, this left the owners with a dilemma. Now that free labor was no longer available to them, they had to come up with ways to make money. They also had to come up with legally binding ways, as a means of financial survival, to make the freedmen work on terms they created. Sharecropping and tenant farming agreements combined with unfair legal treatment is how, some believe, many African American families became immersed in generational poverty.

The following three footnotes found at the bottom of Fayette County tenant agreements (contracts) made between former enslavers and freedman were compiled by researcher Marsha Thompson. Her written notes were: "Neese's Store Acct—1868 (#8677). Wm Neese's Store Acct—1867 (#8677). Wm Neese to Josiah Brown (Freeman) with collateral his cotton crop for the season on farm of Geo C. Dawson;" "Neese's Store Acct—1867 (#8678). Wm Neese to Jefferson Neese (Freeman) with collateral his crops. (Jefferson was probably formerly enslaved by Neese.);" and "(BOS) William W. Ligon to Henry Ledbetter (Freeman) (Land) September 29, 1868."

prenticeship Petition – WM Webb For Minors (Georgiana and Albert)
bate Records – Vol G, page 251-252 Fayette County, Tx – April Term 1867

the County Court of Fayette County, Texas April Term 1867

Hon J. C. Stiehl Judge of Said Court:

e petition of William G. Webb, a citizen of said County, respectfully makes known that he has had among his family two groes who were his slaves, till set free, and since that time they have continued to reside in his family; indeed they had not her or mother to offer to take them, when declared free by the United States Government. One of them is named orgiana, a mulatto girl about eleven years old, and the other is named Albert, of black complexion, and nine years old. e mother of these children died while a slave of petitioner, and since declared free by the Government of the United tes, your petitioner has supported and taken care of them and treated them with all proper kindness, and no one else has vided for them. The father of the girl aforesaid must have been a white man, but who he is, is not known to petitioner. hile the mother of Albert was alive, a negro man by name Peter, then a slave of Peter V. Shaw, claimed the mother as a e, and during the time the child Albert was born, but said Peter has never paid any attention to, or done anything for said ld Albert and has even shown him a father's kindness, and since his freedom, has left petitioner to take care of, and port him, and indeed said Peter, as petitioner believes and charges, is not only an improper person to have the custody control of said child, but is not able to support or properly provide for him. Your petitioner desires to have said ldren apprenticed to him, and proposes to raise them as house servants and to teach them such branches of education to train them in such other occupations as the Court may prescribe. If such as petitioner considers reasonable, and to er into bond and do all else necessary to comply with the law in such cases made and provided. Petitioner further makes own that said children have been members of his family, and have resided in Beat No. 1 of said County, since they were rn; that they are indigent, and not able to support themselves. And further he represents that Isaac Sellers, a Justice of the ace in and for Beat Number One of said County under the provisions of the law in such cases made and provided, have orted said minors to your Honor's court making known in terms of the law, the necessity of apprenticing them to some npetent person, as appears by his report now on file in your said Court, and your petitioner is ready and willing and here ers to receive the apprenticeship of said minors and to comply with the law in every respect. Wherefore he prays that the per orders and reliefs be granted in the premises, &c

illiam G. Webb

Minor apprenticeships were created as a way to help formerly enslaved minors who were orphaned. The system was often abused and used as a ruse to legally enslave Black minors. This apprenticeship petition is that of William G. Webb wanting to apprentice Georgiana, an 11-year-old mulatto child, and Albert, a Black boy, about nine years old. Webb claims that Georgiana has no parents. Albert's mother has passed, so Albert's father, Peter, has agreed to leave him with Webb because he cannot support him. Both children were born during slavery and were likely formerly enslaved by Webb. The possibility exists that Georgiana is the child of an enslaver (possibly Webb), whose mother was sold pre–Civil War. Because Webb stated that Peter claims Albert as his own son, Peter may have been pressured or coerced into apprenticing out his son. Webb promised, in his petition, to teach Georgiana and Albert to read and write and to release them at the age of 21 or marriage. Their actual outcome is unknown, but the probability is high that promises were not kept.

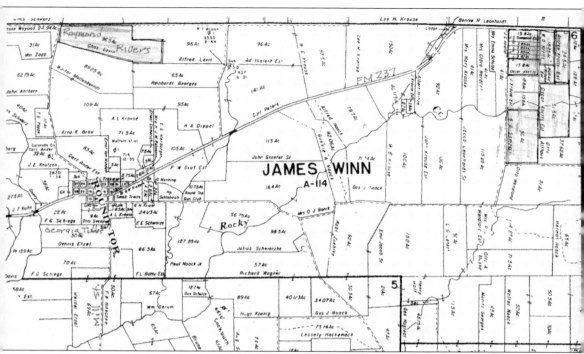

After the Civil War, some African American families in Fayette County, especially in the northern part of the county, who owned land in the James Winn league began to migrate to Lee County searching for new land and new opportunities for building their own homes, raising their families, and starting a new life. Some of the African American families who moved to Lee County and purchased land beginning in 1880 were the Taylors, Huffs, Clemons, Collins, Rivers, Maxwells, Shields, Littles, Garcias, Fletchers, Griffins, Estes, Jacksons, Shepards, Crenshaws, Davises, Whites, Nunns, and McGregors. By January 1901, there were several African American settlements (Freedom Colonies) just north of Ledbetter, Texas, south of the Lee County line by about a half mile. Many of the families who settled in these communities in the late 1800s and early 1900s continued to own their land as late as the 1950s.

Name	Location	Place of Birth	Relationship	Fathers Place of Birth	Mothers Place Of Birth		Anglo Settlers-LEAGUE OWNERS	
							NAME	FROM
has Henry Monroe Huff	5th District	North Caro	Great-Grandfather	North Carol	North Carolina		Samuel K Lewis	South Carolina
h A. Jackson	5th District	Virginia	Great-Grandmother	Virginia	Virginia			
h Griffin	5th District	Georgia					John R Robson	Georgia
ord Griffin	5th District	Texas		Georgia				
a Griffin	5th District	Georgia		Georgia	Georgia		V F Wade	Georgia
ip Griffin	5th District	Virginia		Virginia	Virginia			
Rivers	5th District	Texas		Alabama	Alabama		T B Wills	South Carolina
line Rivers	5th District	Texas		Alabama	Alabama			
Rivers, Sr.	5th District	Texas	G-Great-Grandfather	Georgia	Georgia		Hamilton Ledbetter	North Carolina
a Rivers	5th District	Texas	G-Great-Grandmother	Alabama	Alabama			
Rivers	5th District	Texas	Great-Grandfather	North Carol	North Carolina		William Robinson	Alabama
Rivers	5th District	Georgia	Great-Grandmother	Georgia	Georgia			
h Rivers	5th District	Texas		North Carol	North Carolina		Mary Mott	South Carolina
erline Rivers	5th District	Mississippi		Mississippi	Mississippi			
Rivers	5th District	Texas		North Carol	North Carolina		Sarah Jones	Alabama
ge Moore	5th District	Virginia		Virginia	Virginia			
Taylor	5th District	Alabama		Alabama	Tennessee		Amaziah Baker	
m Rivers	5th District	Texas		Texas	Texas			
Rivers	5th District	Alabama		Alabama	Alabama		Mary Phelphs	
s Clemons	5th District	Virginia	G-Great-Grandfather	Virginia	Virginia			
h Kellough	5th District	Alabama	G-Great-Grandmother	Alabama	Alabama		James Beardslee	
Kellough	5th District	Alabama		Alabama	Texas			
Kellough	5th District	Mississippi		North Carol	North Carolina		Obediah Hudson	
k Shields	5th District	Texas		Kentucky	Alabama			
s Craft	5th District	North Carolina					James Winn	
g Craft	5th District	Texas						
ge Cottonwood	5th District	Texas					William Jacks	
ah Cottonwood	5th District	Texas						
ard Collins	5th District	Texas	Great-Grandfather	Louisiana	Virginia		William Townsend	
dy Clemons	5th District	Texas	Great-Grandmother	Virginia	Alabama or Mississippi			
s Collins	Schulenberg	Tennessee		Tennessee	Tennes		John townsend	
cca Collins	Schulenberg	Alabama		Alabama				
ollins		Alabama		Alabama	Virginia		Joshua Fletcher	
ha Collins		Virginia			Virginia			
s Banks		Georgia		Georgia	Georgia		Nathaniel Townsend	
A		Virginia		Virginia	Virginia			
Collins		Alabama		Georgia	South Carolina		David Shelby	
Collins		Alabama		Alabama				
ge Collins		Alabama			Virginia			
Collins		Alabama						
Leonard		Virginia		Virginia				
Leonard		Georgia		Georgia				
ph Benford	J.P. PCT 2	Alabama		Alabama	Mississippi			
a Benford	J.P. PCT 2	North Carolina		Alabama	Alabama			
les Allen	PCT 1	Alabama		Alabama	Alabama			
g Allen	PCT 1	North Carolina		North Carol	North Carolina			
Pool	PCT 1	Virginia		Virginia	Virginia			
m Banks	PCT 3	Virginia		Virginia	Virginia			
lotte Banks	PCT 3	South Carolina		South Caro	South Carolina			
ph Ledbetter	PCT 3	Texas		Texas	Texas			

This 1880 Fayette County census shows that there were about 50 Black residents living in and around the area of Round Top who were the families of recent freedmen. There was one Black freedman named Major Moore, born in 1805, who was living in town. Moore was very likely freed in the town area and remained there. Also shown are the original settlers who owned leagues of land where many of these newly freed pioneers settled. Shown is a partial list of African American landowners who still own their land today in Fayette County Freedom Colonies.

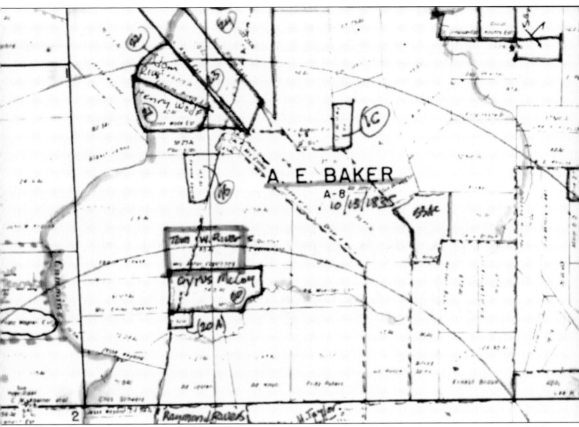

There were four prominent mulatto families who settled in the Round Top area post–Civil War period who carried the surname of several prosperous Round Top–area planters. They were the families of Joseph Ledbetter, born in 1839; Riley Townsend, born in 1851; Erdmann Maxwell, born in 1835; and Benjamin Knotts, born in 1831. By 1870, there were 420 African American pioneers living in the Round Top area. By 1880, Round Top began to grow as a community. In Round Top's Precincts Nos. 2 and 3 alone, there were about 193 dwellings and 1,204 residents in the area. A total of 873 were of German and Anglo descent, and 331 were Blacks and mulattoes. Many of these new freedmen listed their birthplaces as Georgia, Tennessee, Alabama, North Carolina, and Maryland. Most came from Georgia and Tennessee. Shown is a map detailing land that Round Top pioneers owned within a five-mile radius of town. (Courtesy Tobin Maps.)

Four

GENERAL MERCHANTS ZAPP AND STUERMER

Fayette County became home to many German immigrants during the 1840s and 1850s. Along with the Germans, many immigrants from Austria, the Czech Republic, and Bohemia also began migrating to the Round Top, Texas, area. After the Civil War ended, a number of the earlier Anglo settlers decided to sell their land. Due to the loss of free labor, many went into debt, and many could no longer sustain their lifestyles financially. Some headed out farther west, and some returned to their home states. Many of the newer European immigrants began buying up the land from the older Anglo settlers who were leaving. Some of the newly freed Round Top pioneers, rather than return to working for the pioneers who had once enslaved them, began seeking employment with these new German and Czech landowners. A few of these new immigrants, such as the Zapps, the Stuermers, and the Marejowskys, became merchants and opened up general stores. Most of them, despite the times in which they lived and any threats they may have received from disgruntled returning Confederate soldiers or former planters, unapologetically did business with the newly freed Round Top residents.

Robert Zapp was a German immigrant, born in 1820, who served in the 12th Texas Legislature from 1870 to 1873. In 1870, Robert Zapp, a citizen of Round Top, introduced his first bill for the incorporation of Round Top, which passed the same year. Zapp, an engraver, left Germany in 1846 and settled in La Grange, Texas, in 1848. He was one of the German immigrants mentioned earlier both who opposed seceding from the Union and opposed slavery. Zapp opened a general store in 1867 in Round Top and kept track of all his sales and transactions in a ledger. That ledger is of significant historical importance to the African American community. (Courtesy the Texas State Historical Association.)

Because African Americans were considered property, it is rare to find any of them listed by name prior to the Civil War, except in a few wills or business transactions. This 1869 Zapp ledger is historically significant because it lists, by name, actual pioneers who were once enslaved in and around Round Top, Texas. In 1869, there was a lot of political and social unrest occurring in Fayette County because of the end of slavery. Zapp, despite this unrest and possible risk to himself, began doing business with these newly freed pioneers. The author was pleased to see two of his ancestors listed on this ledger: Hattie M. Collins and Matt Rivers. (Courtesy Harley Weyand.)

Among the names of the newly freed Round Top pioneers listed on the ledger are Sam Stowit, Hattie Collins, Matt Rivers, Ball Elder, Dick Anes, Andrew Johnson, Peter Taylor, Bob Gaither, Jim Stowet, George Stowet, Ben Ledbetter, Sam Perry, Amos Sampson, Bunk Taylor (who lived in Carmine next to the Carmine Cemetery in 1890, according to Harley Weyand), Phinex, Wash Wade, Beire White, Adam Rivers, Ned Howe, Will Banks, Jerry Croffet, Joe Nelson, David Holens, Armster (Armstead), Sergel, and Fred Sampson. (Courtesy Harley Weyand.)

Due to the kindness of Robert Zapp and his great-great-grandson Harley Weyand, the following is a list of some of the formerly unknown and unnamed Round Top pioneers who were born into slavery. Newly freed men were going into Zapp's general store and buying items that they were once prohibited from buying or owning. Items such as lead pencils, nails, spools of thread, flour, sugar, and even a quart of whiskey were found on the ledger. (Courtesy Harley Weyand.)

The Stuermer family were among an influx of Germans that migrated to Texas from Germany in the 1840s and 1850s. Ernst Peter Stuermer was born in 1866 in Texas. He was one of the Germans who purchased multiple farms and ranches from the Anglo settlers who left the area. In 1892, he married Freidericha Vanderworth in Fayette, Texas. According to his great-great-granddaughter Christine Dyer-Jervis, he operated a saloon in Rutersville in 1890. A decade later, in 1900, the Fayette County census showed the saloon was still in operation. The following year, Stuermer established the Stuermer General Store in Ledbetter.

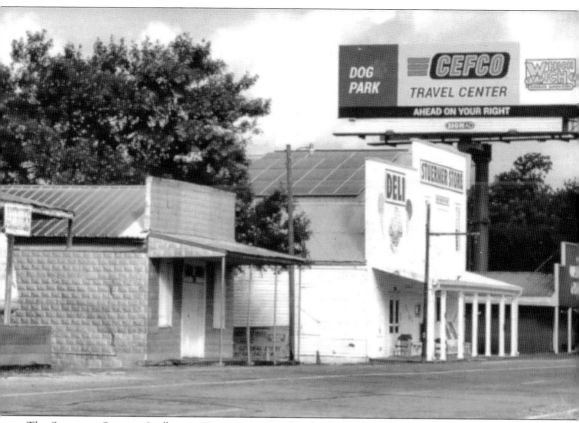

The Stuermer Store in Ledbetter, Texas, was in its heyday between 1900 and the 1920s. Progress caused the town to suffer economically. By the mid-20th century, pioneers were starting to take advantage of newly built highways and were flying to their destinations rather than taking long train rides. When the train services stopped, the various businesses in Ledbetter suffered. In 1934, the town suffered a catastrophic loss when a fire burned a block of buildings on the north side of the railroad, including a general store, a drugstore, a pool hall, and other businesses. The Stuermer Store, despite that tragedy, did not shut down and has continued to thrive well into the 21st century. The great-great-granddaughter of Ernst Peter Stuermer, and her mother, Lilliam Lenora Stuermer-Dyer, continue to operate the store today. (Courtesy Wikimedia Commons, Larry D. Moore, CC BY-SA 4.0.)

The Stuermer Store, after more than a hundred years, is still in operation today. It is a Texas treasure that many travelers consider a historical must-see when driving between Houston and Austin. People who have visited the store have been impressed by the its upstairs museum, which has displays of general store merchandise from yesteryear.

Five

FREEDOM COLONY
CHURCHES AND SCHOOLS

When enslaved Africans were brought to America, many came with their own set of religious beliefs and customs. Some came to America as practicing Muslims. In the 1800s, enslaved pioneers became exposed to Christianity when the Protestant evangelism movement began to spread throughout America. The more enslaved pioneers learned about the Christian religion, the more hope they began to have for eventual freedom. After the Civil War ended, enslaved pioneers all over Texas and the South began using the church as a communal vehicle to build communities. Between the years 1866 and 1900, there were 58 churches that belonged to the 1875 La Grange Association of African-American Churches that were built by their area's newly freed pioneers. They were in communities as varied as Bethel Union and Corinthian in Lee County, Concord and Mount Olive in Fayette County, and Center Union and Little Flock in Bastrop County—the list goes on. Enslaved pioneers, once slavery ended, did not sit lazily around waiting for someone to rescue them economically; they rescued themselves, using the church as their vehicle. Two churches that were instrumental in creating the Freedom Colonies that sprang up in and around Round Top were Connersville Primitive Baptist Church and Concord Missionary Baptist Church.

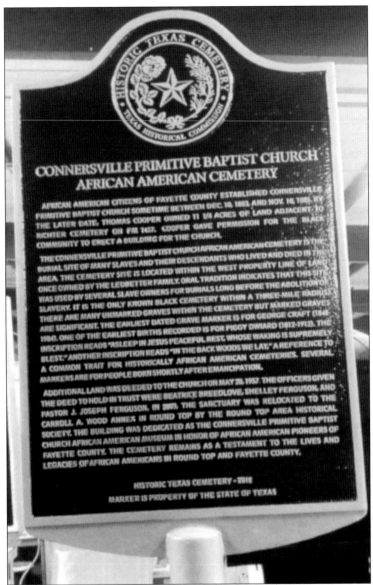

Based on old county survey maps, in the Fayette County Annex, there was a site labeled "Colored Church" located on the south line of the James Winn league (south line of the George Wagner property) and its intersection with the northeast corner of Richard Wagner's property. This is northwest of the intersection of Hackenmack Road and FM 1457. This original "Colored Church" was probably torn down, leaving no recorded history. The Connersville Primitive Baptist Church's recorded history began on December 10, 1883. Thomas Cooper of Lincoln County, Oklahoma, purchased 11.25 acres of land from Thomas Albert Ledbetter, a son of William Hamilton Ledbetter. This land was described in the deed as being adjacent to the "Old School Presbyterian Church and Round Top Academy" land. Today, this is the vicinity of the Richter Cemetery on FM 1457. Cooper gave permission for the Black community to build a church—the Connersville Primitive Baptist Church. This would indicate that the original Primitive Baptist church was the original "Colored Church" that was located some 1,100 feet southeast of the current Connersville Primitive Baptist Church Cemetery and the Richter Cemetery.

[Handwritten deed text, largely illegible]

Know all Men by these Presents That we, Thomas Cooper and his wife ...

Two years later, on November 10, 1885, Cooper sold 10.5 acres of this land to William Zander, reducing the original acreage to three quarters of an acre. In September 1893, Thomas Cooper deeded the land to the Connersville Primitive Baptist Church for $1. The deed gives no metes and bounds description but merely states, "Immediately surrounding the present site of the Primitive Baptist Church." (Courtesy the Round Top Historical Society, Herb C. Diers.)

It is not known when the congregation ceased using its church at this original site, since there is no recorded history. In an apparent desire to build a new church, a group of individuals, the descendants of pioneers who were earlier enslaved, purchased .65 of an acre of land from Richard and Hannah Wagner for a new church site. To note, part of this same tract of land was previously owned by the Primitive Baptist church, with no record of it ever being sold. Officially, the property was deeded to the Connersville Primitive Baptist Church on May 20, 1957, for $243. Descendants of the original pioneers then put the church in a trust. The first trustees in 1957 were J.J. Ferguson, Shelley Ferguson, and Beatrice Breedlove. J. Joseph Ferguson was the pastor of the Primitive Baptist church at the time. He is one of the many parishioners interred in the church's historic cemetery. As mentioned, many of the descendants of the enslaved pioneers who belonged to the Ledbetter family and other slave-holding families are also buried there. (Courtesy the Round Top Historical Society, Herb C. Diers.)

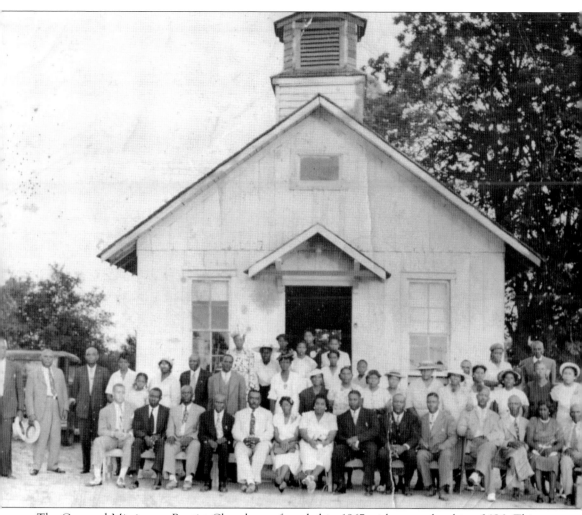

The Concord Missionary Baptist Church was founded in 1867 with a membership of 186. This was just two years after slavery ended. Concord Church is noted for its contribution to educating Round Top's early pioneer freedmen post–Civil War. It is located at 437 North Washington Street (Highway 237) in Round Top, Texas. As noted earlier, African Americans often used the church as a place to do business. They did this because during the Jim Crow and segregation years, oftentimes White bankers would not do business with them. One recorded example is a business transaction conducted among Concord Church members on December 20, 1892. Round Top residents Arch Leonard, Thomas Rivers, and Adam Rivers paid a sum of $100 to Round Top Church trustees J.C. Benford, Thomas Shelby, and Jerry Crawford to buy two acres of land on the east side of Highway 237. This was part of a business transaction being brokered between Isaac Killough and his wife to Arch Leonard, Thomas Rivers, and Adam Rivers, with the church acting as an intermediator. (Courtesy the Round Top Historical Society, Georgia Etzel-Tubbs.)

The Concord Missionary Baptist Church continued to grow as the years passed. This church roll was recorded by the church secretary in 1931 with approximately 100 members attending. This usually indicates that this was the first Sunday of the month. This roll confirms that there were many African Americans living around Round Top, Texas. Some of the names familiar to the author are the Crumps, Rivers, Shelbys, and Collins, as they are the author's ancestors. A review of church attendance records shows that although some years church attendance was spotty, there was never a year when attendance was nonexistent. Attendance numbers ranged from 14 pioneers who attended church the first month in 1927 to 117 pioneers who attended during a summer special gathering in 1932. (Courtesy Concord Missionary Baptist Church, Maude Cole.)

This church roll is from the original secretarial journal kept by Maude Cole, church secretary for Concord Missionary Baptist Church, which was founded in 1867 in Round Top, Texas. This original handwritten attendance list is one of the Sundays in 1928. Throughout the years, the church has undergone several renovations. After each renovation, the parishioners, to honor the church's history, have tried to keep the same floor plan, building foundation, and framing. The original site of the church has not changed in 156 years. It is located at 437 North Washington Street (Highway 237) in Round Top. The church's name has been changed to the City of Refuge Church. (Both, courtesy Maude Cole.)

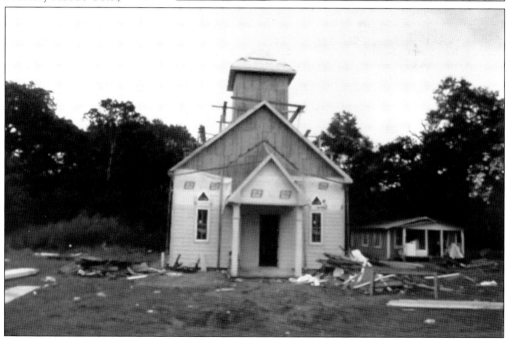

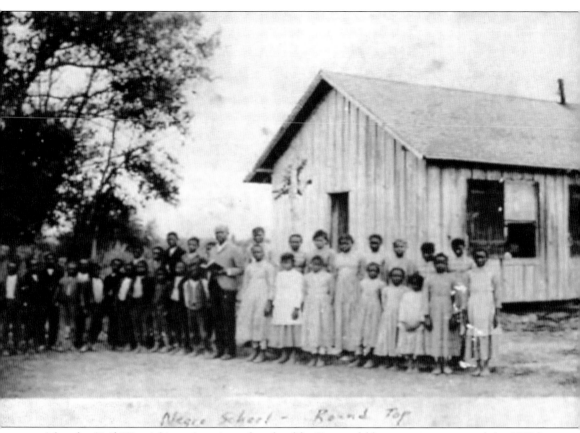

Negro School - Round Top

After the Civil War, African American churches like Concord (shown as it was around the 1910s) had to wear many hats. In addition to being a place of worship and a place to do business, it also had to be a place of learning. Despite needing their children's help on the farm, Round Top freedmen willingly sacrificed having that extra help because it was important to them that their children learn to read, write, and understand mathematics. Concord Baptist Church provided that learning environment for them. Many newly freed men, desperate to learn to read and write after the end of the Civil War, flocked to the Freedman Bureau schools that were being established during that time. After these schools closed, many of the men and women who received a basic education from these schools went on to teach others in their community. Some were able to continue their education by enrolling in the emerging Texas African American colleges of the time, such as Prairie View A&M, established in 1876; Paul Quinn in 1872; and Wiley in 1873. (Courtesy Round Top Area Historical Society, Georgia Etzel-Tubbs.)

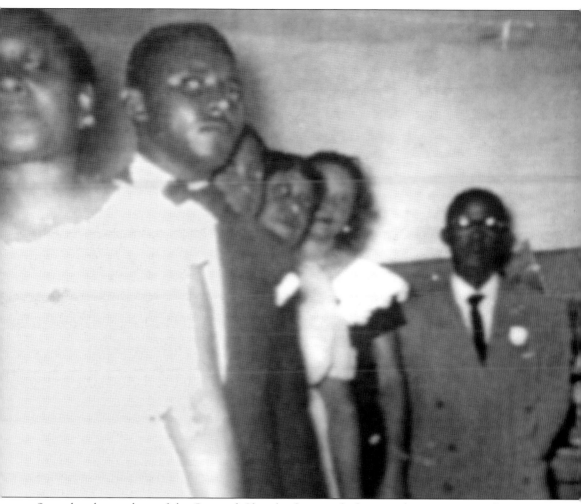

Several early members of the Concord Church who were lucky enough to receive an education post-slavery took on the responsibility of educating the children of the Round Top pioneers. One such person was Calvin Lindley Rhone Sr. He was born on October 20, 1861, in Natchez, Mississippi. In addition to being a teacher, he was also an industrious farmer who at one time owned 203 acres of land along Round Top Road. His wife, Lucia J. Knotts-Rhone, born in 1866 in Texas, also taught at the school with him. Calvin and Lucia were responsible for creating an educational dynasty that lasted a hundred years or more in Round Top. Their descendants would continue their legacies as educators. The history of this family is so well appreciated that the Rhone Family Papers are currently stored at the Dolph Briscoe Center for American History in Austin. According to the 1900 Fayette County census, there were about 474 African American families living in the Round Top area, so the need for a school was fairly obvious. (Courtesy Round Top Area Historical Society, Georgia Etzel-Tubbs.)

The Rhone family was a family of Round Top educators. As mentioned, Calvin Lindley Rhone Sr., born in 1861, and his wife, Lucia Knotts, born in 1866, created a legacy of educators. One of his 12 children, a daughter named Urissa Rhone-Brown, became a well-respected educator in Round Top. She attended the historic African American university Prairie View A&M. Urissa was born on February 17, 1901, in Round Top. In the late part of the 19th century and into the mid-part of the 20th century, African American schools, particularly in rural areas, were considered a separate school system. Urissa, as an educator, started out working in the segregated "colored" school system. After the civil rights movement of the 1960s, the Round Top School System was officially integrated into the Carmine Independent School District, where Urissa worked her way up to becoming principal of the school. (Courtesy Round Top Area Historical Society, Georgia Etzel-Tubbs.)

This letterhead is from the famed World War II Tuskegee Army base. Urissa Rhone-Brown's nephew Fred was stationed at the famed Tuskegee Army Flying School and Army base in Tuskegee, Alabama. The Tuskegee Airmen were African American fighter and bomber pilots. Although Black aviators such as Bessie Coleman, born in 1892 in Atlanta, Texas, have existed since the invention of flight, due to America's stringent Jim Crow culture, Black pilots were not given the same opportunities to fly as White aviators. During World War II, Tuskegee Airmen were awarded three unit citations because of their combat record—a rarity. Today, the US military is committed to recognizing World War II acts of bravery committed by all Black soldiers. Fred mentions that he attended Prairie View A&M and the historically Black Talladega College in Alabama prior to being drafted and that he is a physical training instructor at the Tuskegee Air Field. (Both, courtesy Round Top Area Historical Society, Georgia Etzel-Tubbs.)

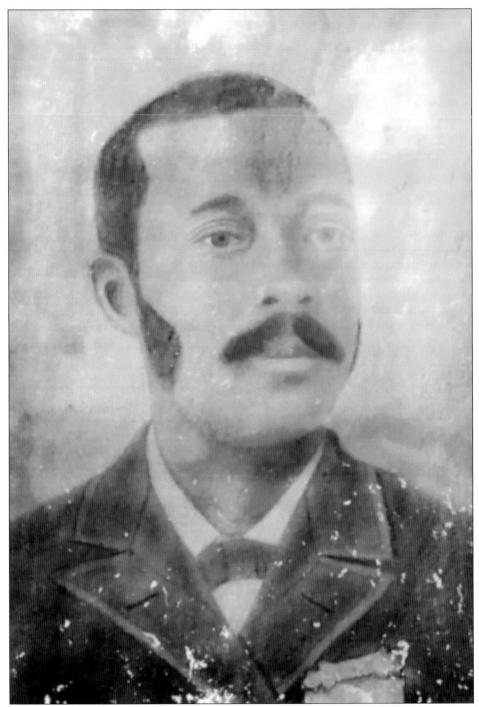

Another early Round Top teacher was Madison Knotts. In the early 1900s, he was both a teacher and the principal at the Concord School. Madison was born on January 29, 1884, to Oscar Knotts (born 1860) and to Julian Sampson (born 1865); both were born in Texas. According to the locals, Madison attended college for two years and dedicated his life both to educating Round Top's children and to farming.

Pearline Knotts-Burrell, born in 1925 to Calvin and Mary Knotts, was another outstanding family member to teach at Round Top. She was another educator who, despite not being given the same up-to-date books or materials as her contemporaries, was able to successfully educate more than one generation of Round Top students. (Both, courtesy Round Top Area Historical Society, Georgia Etzel-Tubbs.)

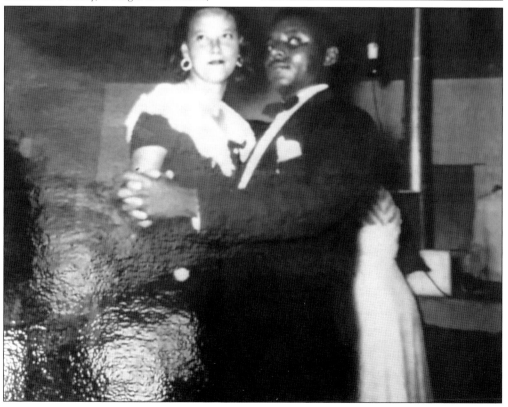

Shown are Round Top students Ruthie Anderson (left) and Florence Shelby. They are just a few of the students who were taught by teachers from the Rhone and Knotts families at the Round Top Colored School during the days of segregation. Many Rhone and Knott students went on to have successful professional careers. (Both, courtesy Round Top Area Historical Society, Georgia Etzel-Tubbs.)

Although separate but equal was the law of the land, Black schools in the late part of the 19th century and into the mid-part of the 20th century were never given equal access to monies to fund their schools. Oftentimes, it was the community and the teachers, like the Rhone and the Knotts families, who had to help the schools get the supplies they may have needed. Both the Rhone and the Knotts families, in addition to teaching, also farmed. (Right, courtesy the Round Top Historical Society, Georgia Etzel-Tubbs; below, courtesy Jennifer Kitchen.)

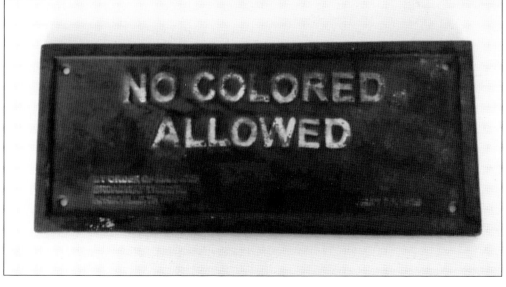

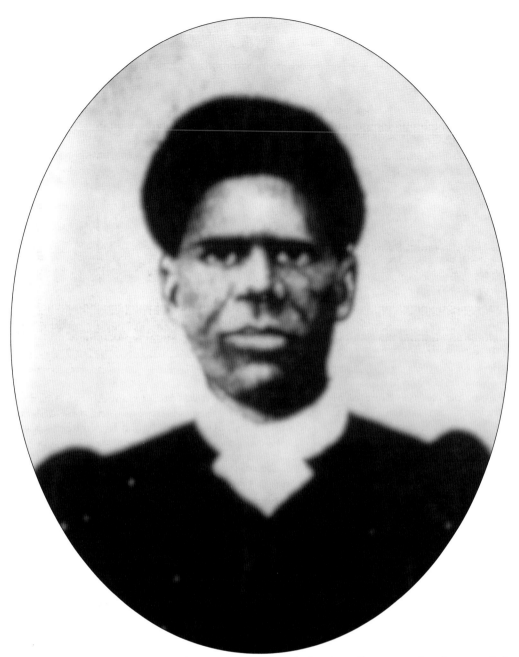

Thomas Henry Monroe Huff was born in 1847 in South Carolina. Five years after slavery ended, Thomas was living in Brenham, Texas, and teaching school. How and where he learned to read and write and where he was educated is unknown. By 1880, Thomas had made his way to Fayette County and began teaching school there as well. He married Sarah Jackson, who was born enslaved on May 10, 1849, in Virginia. Together they had five sons and nine daughters. They lived in the Fifth District of Fayette, Texas (Round Top). Sarah died in 1926 in Giddings, Texas, at the age of 77.

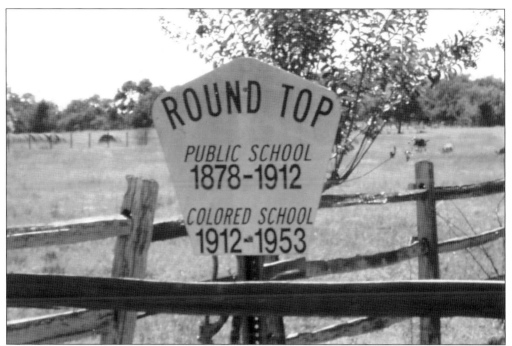

When the Civil War ended, many newly freed men and women were eager to learn to read, write, and understand mathematics. These were things that they were legally prevented from doing as enslaved people. The Concord Missionary Baptist Church was one of many African American Freedom Colony churches that provided an education for the newly freed men and women. Shown are markers in the Round Top area that denote the original location of Round Top's colored schools. The 1878-dated sign is located on the northeast corner of the Diers property on Mill Street in Round Top, which is directly across the street from the Round Top Post Office. The 1890-dated sign is on the original site of the Concord Missionary Baptist Church. The original word "colored" has been painted over.

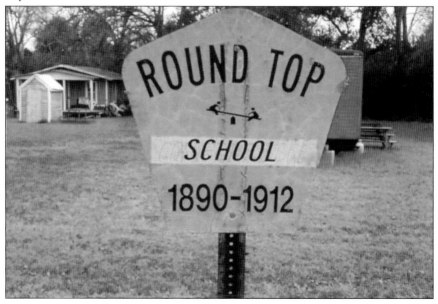

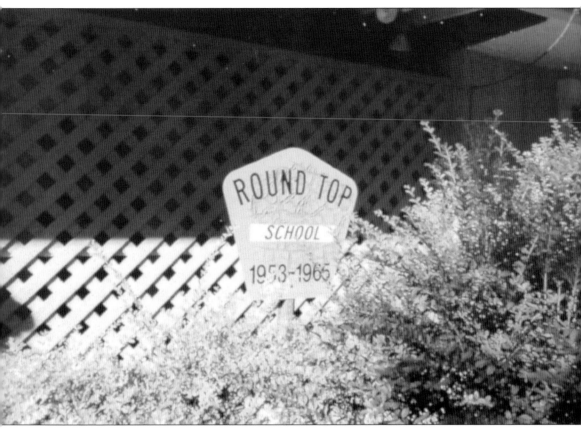

This Round Top sign dated 1953 is located on the southwest side of Round Top's Festival Hill dorms on Jaster Road. The sign originally read "Round Top Negro School." The era of the colored school system came to an end gradually as it became more and more difficult to maintain two separate school systems.

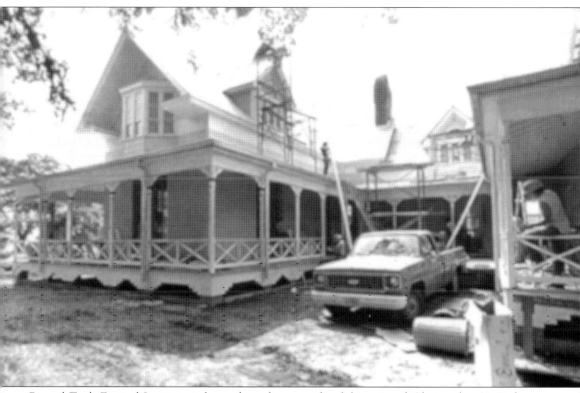

Round Top's Festival Institute is located on the grounds of the original Christopher H. Taylor Plantation. This site was the location of the Round Top Colored High School from 1952 until about 1970. The Festival Institute was established by University of Texas graduate and concert pianist James Dick in 1971. Dick was very distinguished in that he received two Fulbright Fellowships to study at the Royal Academy of Music in London He was named a Chevalier des Arts et Lettres by the French Ministry of Culture in 1994. In 2003, James Dick was appointed Texas State Musician. He received the 2009 Texas Medal of Arts for his work in the area of arts education.

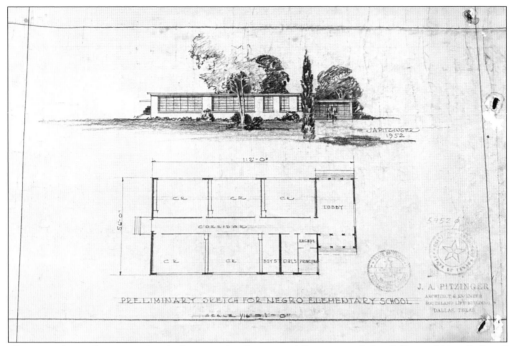

Shown is the preliminary sketch drawing for the Negro Elementary School (Round Top Colored School) that was thankfully preserved by Jennifer Kitchen, a board member of the Round Top Area Historical Society. Her grandfather Alvin M. Rauch was one of Round Top's school board members. The actual school building shown is now on the property of the Festival Institute and is used as a Festival Institute dorm. (Both, courtesy the Round Top Historical Society, Jennifer Kitchen.)

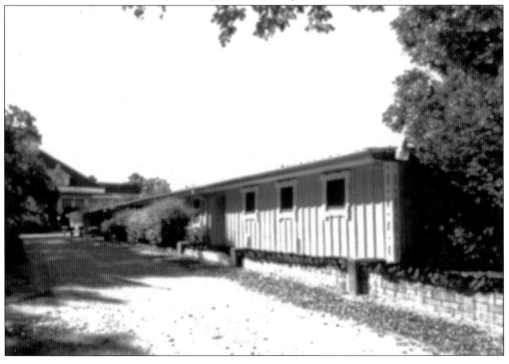

Six

FACES FROM
THE PAST

Complete in-depth biographies of Round Top, Texas, African Americans who lived pre–Civil War and during the Reconstruction period are challenging to write because of the American institution of slavery. Therefore, it is historically important to show pictures of the early African American Round Top pioneers and their children and include information, no matter how small, about them along with their photographs. W.E.B Du Bois, a historian and a 19th-century civil rights leader, had an exhibition of African American pictures shown at the 1900 Paris Exhibition. He did this exhibition because he was troubled by the stereotypical portrayals of African Americans that were appearing in the American print media at the time. Although many of the stories and faces of the original pioneers have been lost to time and erased due to slavery, the spirit of these earlier pioneering settlers, through ancestral memory, still lives on. The following is just a small sampling of the pioneers who helped create the community of Round Top, Texas.

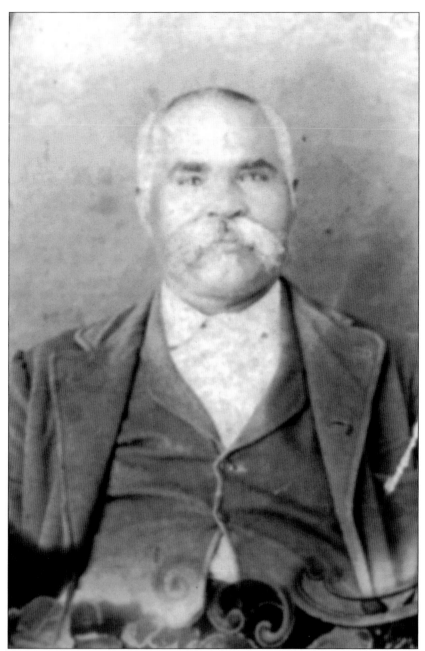

Elijah L. Griffin was an early entrepreneur who lived in Round Top. He was born enslaved in Georgia in 1853. The Griffin family, including Elijah's son August and his brother Sanford, managed to buy 298 acres of land in the William Johnson league and 87 acres of land in the Friend Boatwright league in Lee County. They were early entrepreneurs who joined other Black farming families and owned and operated a cotton gin on Nails Creek. Some of the farmers they joined were Will and Jasper Crenshaw, Bob Johnson, Wiley Hancock, Duncan McCoy, Tobe Soloman, and Parker Shepard. The Griffin family were neighbors and friends of the author's family, the Taylors. Elijah's wife was named Henrietta Francis, and she was born enslaved in 1856 in the Freedom Colony of Antioch, Lee County, Texas. Together, they had about seven children. (Courtesy Katie Mae Taylor-Griffin.)

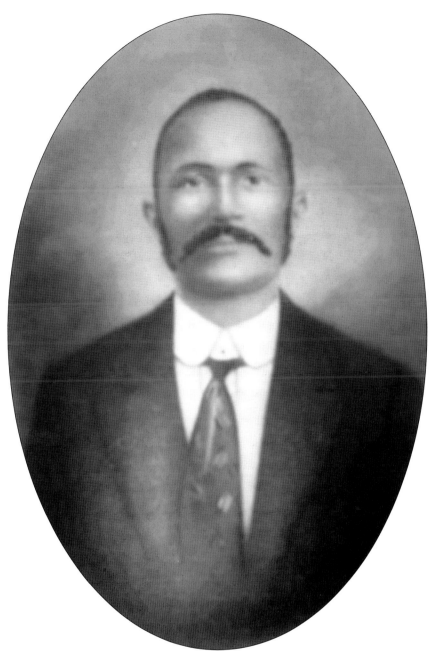

John Wesley Taylor was born on October 16, 1866, in Fayette County, Texas, and died on August 18, 1918, in Bexar County, Texas. He was born to Wesley Taylor (born in 1846 in Virginia) and Annie Marcus of La Grange, Texas. John had a sister, Eula, who was also born to this union. However, John Wesley and Eula were Wesley's offspring born to him outside of his marriage to another person. John Wesley grew up in Fayette County, where he met Katie Rivers, and they married on August 24, 1883. Katie (born 1864 in La Grange, Texas) was the daughter of Matthew Rivers Sr. and Sabry Daws. Katie had a brother named Tom. Tom and his wife, Channie Maxwell-Rivers, were living on Frank Wagner's place, which was located just north of Round Top on Round Top Road and Weyand Road. (Courtesy Lena Katheryn McNeal-Smith.)

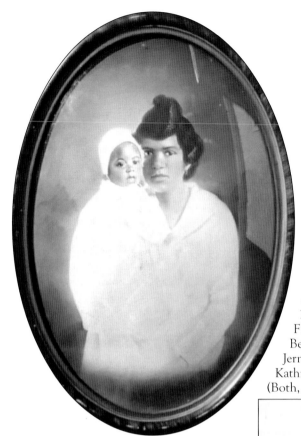

Mattie Taylor (pictured), John Wesley Taylor and Katie Rivers-Taylor's third child, was born on August 21, 1894, in Giddings, Texas. She died on October 21, 1988, in San Antonio, Texas. During the course of her life, she married Flem Rucker and Alex Jernigan. Alex was born on September 26, 1888, and died in March 1985 in San Antonio, Texas. Mattie and Flem Rucker had one child, named Lena Bell. Matti and her second husband, Alex Jernigan, had one adopted child, named Lena Kathryn Jernigan, born on September 28, 1939. (Both, courtesy Lena Katheryn McNeal-Smith.)

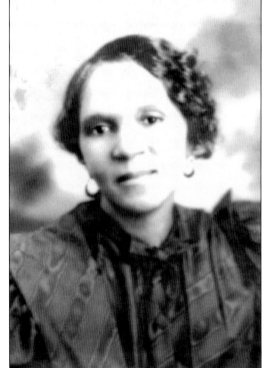

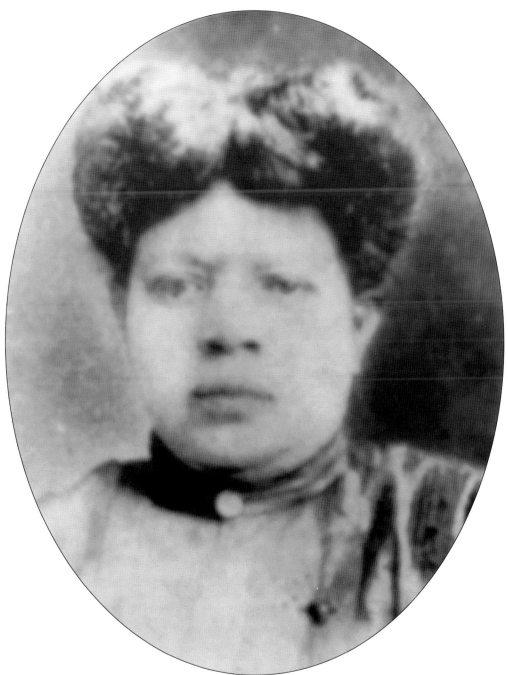

Chanie Maxwell was born in March 1867 in Fayette County, Texas. On December 21, 1882, she married Thomas Rivers, son of Matthew Rivers Sr. and Sabry Daws. Thomas was born in 1860 in La Grange, Fayette County, Texas. Thomas and Chanie had a total of 15 children between 1883 and 1910. Chanie was a very busy woman raising her children over a period of 44 years until she died in Sweet Home, Lee County, Texas. She had a child in 1883, 1884, 1887, 1889, 1891, 1982, 1894, 1896, 1897, 1899, 1900, 1902, 1905, 1908, and 1910. Her youngest child, Almeda Rivers, was 17 years old when she died. (Courtesy Katie Mae Taylor-Griffin.)

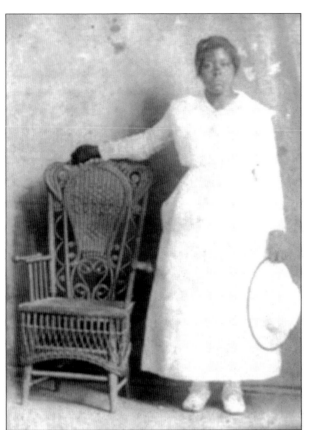

Malissa Hopson was born in Round Top, Texas, in 1895. She was the daughter of Annie Land, born in 1867, and her first husband, John Hopson, was born in 1867. Malissa married David Rivers on January 7, 1920. David was born in about 1890. (Courtesy Beatrice Crump-Rivers.)

Matthew Rivers Sr. was born in 1832, when Texas was still a part of Mexico. Matthew Rivers Jr., his son, was born in 1866. Matthew Jr. is buried in the historic Connersville Primitive Baptist Church Cemetery. The Rivers' oral family history describes him as a very proud man who would ride into Round Top town on his beautiful majestic white horse to do any shopping he needed at the local general store.

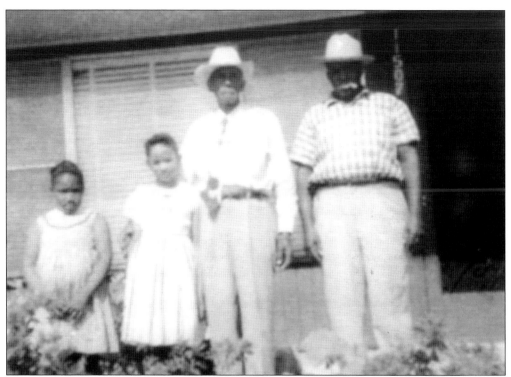

David Rivers was an entrepreneur at heart and developed a profitable chicken farm. Because of his determination and hard work, an article was published in the old *La Grange Journal* dated 1946 (shown). Above is Matthew Rivers Sr. with his son and granddaughters. David Rivers was the son of Thomas Rivers and Channie Maxwell-Rivers of Round Top, Texas. They lived on the Frank Wagner Place on the west side of Weyand Road and Round Top Road. Thomas was the brother of Katie Rivers and Matthew Rivers Jr. of Round Top, Texas. Katie Rivers married John Wesley Taylor of La Grange, Texas. In 1920, David married Malissa Hopson, and together, they purchased 125 acres of land just west of Highway 159. (Above, courtesy of Beatrice Crump-Rivers; right, courtesy Rox Ann Johnson, Fayette County Historical Commission.)

Colored Farmer Pays FSA Farm

The above photo, furnished by the Fayette county Farmers Home Administration, shows David Rivers and dife, with a portion of their large flock of laying hens. Rivers recently paid his farm loan out in full, from earnings derived entirely from the farm.

Monday, Dec. 2, 1946, David Rivers came to the office of the Farmers Home Administration at La Grange, and paid his loan in full.

Rivers was one of the first negroes from among the various applicants to be eligible to purchase a farm in 1938. Rivers' papers were completed and he took charge in July that year. At the time Rivers made application he was a tenant farmer living on the same farm that he now owns. His net worth at the time he made his application was about $11.65. He now has his farm paid for which was valued at $3350, in 1938. He has paid for this from the sale of agricultural products. This includes crops, livestock (cattle and hogs), chickens, milk and eggs. David says, must have the biggest credit. He started with about 300 chickens and at one time has as many as 2500 laying hens. He has at this time reduced his flock to __ hundred hens.

Davi__

farms of this area. He has cooperated with the county agent, the Agricul...

the Soil and Water Conservation program. His whole farm is terraced and his pastures are sodded to some fine grasses. He now has 15 head of cattle but expects to increase this part of his program. He has eight acres fenced hog proof and has at times made considerable from the sale of pigs and hogs.

During the time Rivers was building up his poultry and livestock program he found that he had a shortage of water supply. He came to the office and made a loan to purchase an electric pump and pressure tank which now affords ample water supply. At this same time he was able to get the Rural Electrification Services to wire his farm for electric services.

He now figures his net worth is between six and seven thousand dollars. Rivers has made excellent progress and now feels the sense of security of a home owner.

———oOo———

Home Building Restrictions Off

WASHINGTON.—President Truman the week-end opened up home building to all citizens, wiped out the housing priorities system and removed the $10,000 sales ceilings, on new __

Along with this sweeping liberall...

Wesley Taylor was the author's grandfather. He was born on April 16, 1886, in La Grange, Texas. In 1911, he married Josephine Little. Wesley is one of the tenant farming pioneers whose name appears in the Ledbetter, Texas, Stuermer Store ledger. The ledger illustrates how life was for Wesley as a tenant farmer. When the farming season would end, Wesley would go to market to sell his crop. If, after selling his crop, he did not receive enough money to cover his credited purchases, he would have to carry a debt over into the next year. In addition, he would have to perform odd jobs just to financially survive until the next planting season. If, at the end of the farming season, he had a good crop and was able to sell it all and make a profit, not only would he make enough money to cover his credited purchases, but he would also be able to afford a few extras in life for himself and his family that year. Wesley died on April 30, 1980, in Giddings, Lee County, Texas.

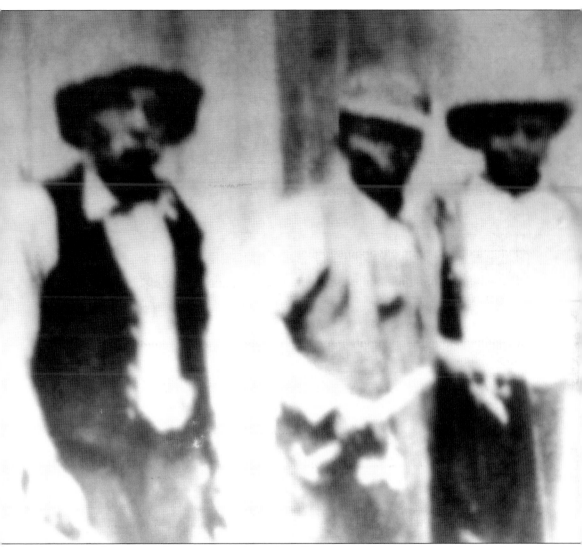

Thomas H. Clemons was born on December 16, 1863, in Fayette County, Texas. Thomas, shown on the left above with two of his cousins, was a master carpenter born near Rutersville, just south of Round Top. He married Caroline Baker on October 7, 1886. His father, Whales Clemons, was born enslaved on December 14, 1829, in Amelia County, Virginia. He married Sarah Killough, who was born in 1828. During his lifetime, Whales wanted to see his community thrive. To help make this happen, he donated one acre of his land to the Sandy Point community so that it could build its own church and cemetery. Whales died in 1906, and Thomas followed in 1944; both passed in Lee County. (Courtesy Yulanda Fletcher.)

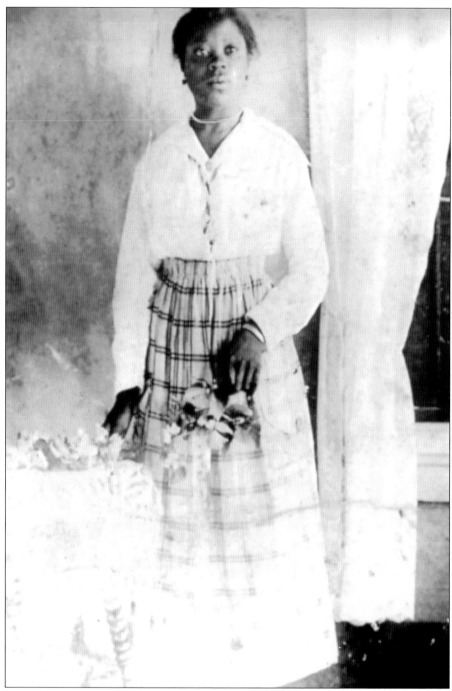

Caroline Baker was born on February 10, 1863, in Louisiana. She died on January 12, 1960, in Sandy Point, Lee County, Texas. On October 7, 1886, she married T.H. "Tom" Clemons, son of Whales Clemons and Sarah Kellough. Tom and Caroline were the proud parents of seven children. Their names were Clara, Amanda, Ruby, Joanna, Sarah, Whales, and Henry Clemons. The Sandy Point Cemetery is located southeast of New Dime Box, Texas, on County Road 426. The Sandy Point Church, once located in the same area, was moved to FM 141. (Courtesy Yulanda Fletcher.)

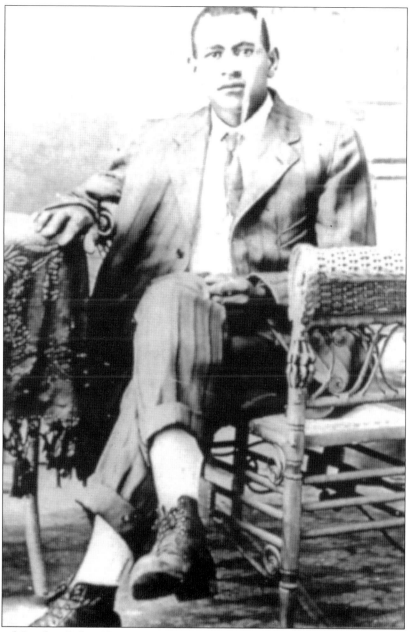

Thomas and Caroline Baker-Clemons named their sixth child after Thomas's father, Whales. Wales Clemons was born on December 14, 1896. His father was born in Fayette County in 1863 to Whales Clemons and Sarah Kellough, who lived in the Nechanitz, Texas, area. In 1921, he married Sussie Collier in Post Oak, Lee County, Texas. The daughter of William N. Collier and Chanie Scott, she was born on July 2, 1902, in Bellville, Austin County, Texas. Wales and Sussie were the proud parents of three children: Charlene, Olivett, and Vella Clemons. His daughter Olivett turned 90 years old on September 22, 2013, and, at that time, continued to live just south of New Dime Box, Texas, on the family estate. In the mid-1890s, Wales's grandfather Whales Clemons moved his family to Sandy Point, Lee County, Texas, and purchased land to support and raise his growing family, which eventually reached 11 children by the turn of the century. (Courtesy Yulanda Fletcher.)

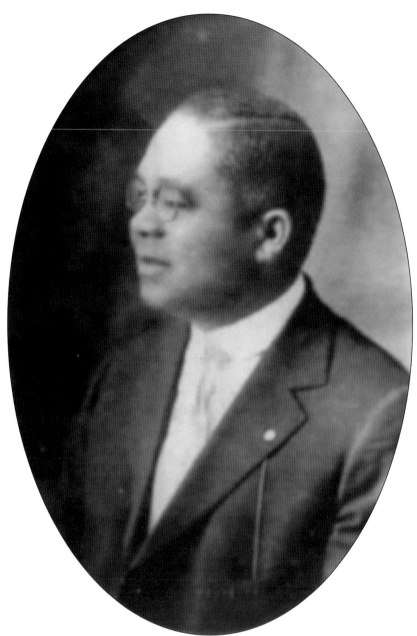

Another of Whales's sons was named Samuel Huston Clemons. He was born on December 10, 1873, in Fayette County, Texas. In 1900, in Milam County, he was 26 years old, married to Rose Lawson, and had two sons: Cyrus and Eddie. Samuel left Texas to pursue a career in medicine at Meharry Medical College, a renowned Black medical college in Tennessee. By 1920, Samuel and his family were living in Tennessee, and he had become a very prominent physician. By 1920, Samuel had presumably remarried to Cora D. Clemons and had children Caroline Clemons and Samuel H. Clemons Jr. A year later, he died. *The Chattanooga Daily Times*, dated January 13, 1931, reported on his death: "Dr. S. H. Clemons—Funeral services for Dr. S. H. Clemons, prominent colored physician who died Wednesday, will be held at Christ Church, McCallie avenue, and Douglas street at 3 o'clock this afternoon. Internment at Forest Hills, with Trimble's in charge."

Edward Collins Sr. was born on June 12, 1886, in Nechanitz, Fayette County, Texas. He was the son of Richard Collins and Mandy Clemons. By 1880, Richard and Mandy, born in Virginia, were living in Nechanitz, which is approximately 10 miles north of La Grange, Texas, along County Road 2145 (west of Highway 77). Ed Collins's siblings were named Ira, Hugh, General Sr., and Gertrude Collins; they were all born in Nechanitz. Ed Collins's grandmother was Sarah Kellough-Clemons, who was the wife of Whales Clemons. (Courtesy Miltrue Cotton-Collins.)

George Huff was the son of schoolteacher Thomas Henry Monroe Bluff. He was born on May 31, 1883, in Ledbetter, Texas. He married Ada Jackson, who was born on January 16, 1886, in Ledbetter, Texas. Over the course of their marriage, George and Ada had an astounding 22 children, 18 of whom lived a full life. Ada, God bless her heart, died on February 11, 1961, in Ledbetter; she was a remarkable woman. (Courtesy Dorothy Huff.)

Hattie Taylor was born on July 4, 1895, in Bell, Texas. Her father, John, was 33, and her mother, Katie, was 31. She married Dewitt Clinton Ray on February 23, 1917. They had eight children during their marriage. She died on May 11, 1980, in San Antonio, Texas, at the age of 84 and is buried in Giddings, Texas. (Courtesy Katie Mae-Taylor Griffin.)

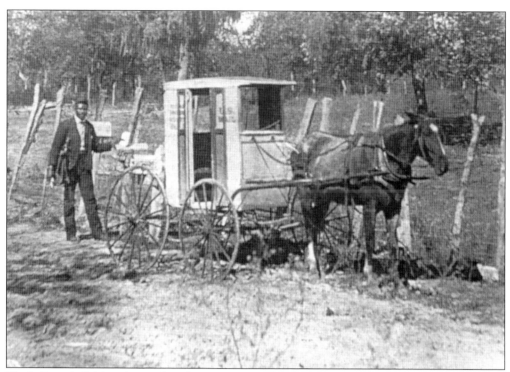

Elijah Campbell (above) served as the rural carrier for Ledbetter, Texas, from February 16, 1906, to December 16, 1937. Elijah lived in Lee County, Texas's Sweet Home community, and attended the Sweet Home Baptist Church. He was born on February 6, 1885, in Lee County. Some time before 1906, Elijah moved to Ledbetter (named after the famed local Hamilton Ledbetter family), which was a stop on the Bastrop-Winedale stagecoach route beginning in 1846. When the Texas & New Orleans Railroad was built and routed to Ledbetter in 1870, the town for a short time became the business hub of the county until La Grange replaced it as the county's railroad center. The US Post Office was established in La Grange on June 27, 1871. Shown at right is Elijah's wife, Ester. (Both, courtesy Vivian Francis.)

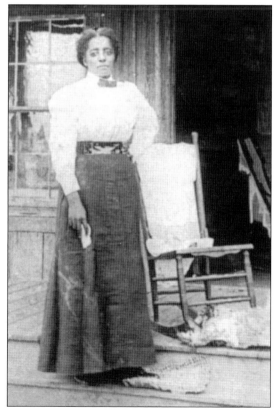

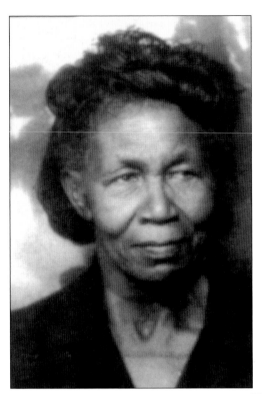

Gertrude Collins was born on June 6, 1882, in Fayette County, Texas, and died on November 3, 1959, in Giddings, Lee County, Texas. She was married to Pinkus Humphrey, who was born in 1880 and passed away in 1942 in Sandy Point, Lee County, Texas. The Humphreys were the proud parents of 10 children. (Courtesy Dorothy Huff.)

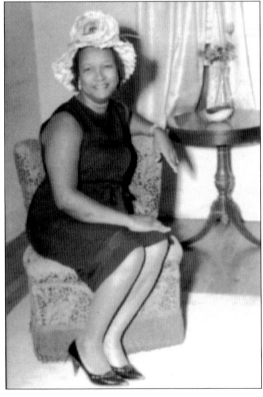

When Hattie Taylor was born, her father, Wesley Taylor, and her mother, Josephine Little-Taylor, lived near Ledbetter, Fayette County, Texas. Hattie Taylor had one brother (James Wesley Taylor) and four sisters (Elvira, Erma, Katie, and Maggie Taylor). She was born on February 21, 1927, in Ledbetter. (Courtesy Katie Mae Taylor-Griffin.)

Shown are John and Rachel Hughes Taylor of La Grange and the surrounding area of Muldoon, West Point, and Plum. Rachel Veola Hughes-Taylor was born on September 30, 1925, in Muldoon, Texas. She married John C. Taylor on December 20, 1942, in Fayette, Texas. They had six children during their marriage. John C. Taylor was born on April 28, 1901, in Fayette, Texas. He was the son of Harriett and John Taylor. Rachel died on May 7, 1994, in La Marque, Texas, at the age of 68 and is buried there. John died on April 3, 1983, in La Marque at the age of 81 and is also buried there. (Courtesy Pamela Collins.)

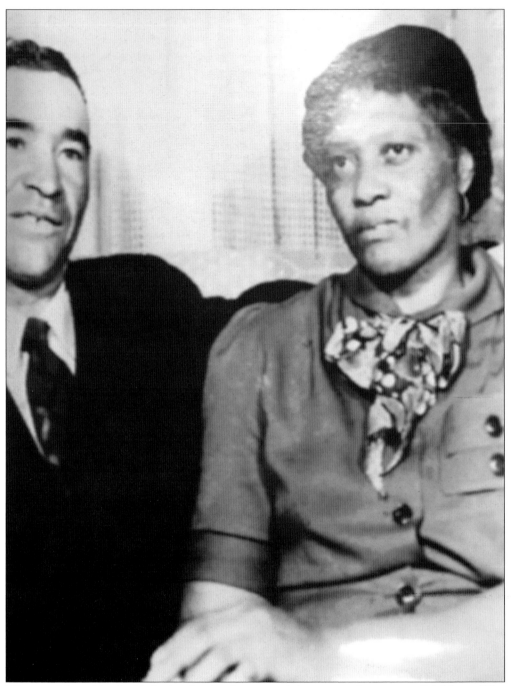

Elbert and Irene Vaughn-Taylor lived in La Grange and the surrounding areas of Muldoon, West Point, and Plum. Elbert Taylor was the son of John W. Taylor Jr. and Harriet Posey Pope. Irene Vaughn-Taylor was the daughter of Sip Vaughn and Adeline Vaughn. Elbert Taylor was born on October 9, 1904, in Fayette, Texas. He had one daughter with Irene Vaugh-Taylor in 1927. He died on March 21, 1970, in Galveston, Texas, at the age of 65 and is buried in Hitchcock, Texas. (Courtesy the Taylor and White families.)

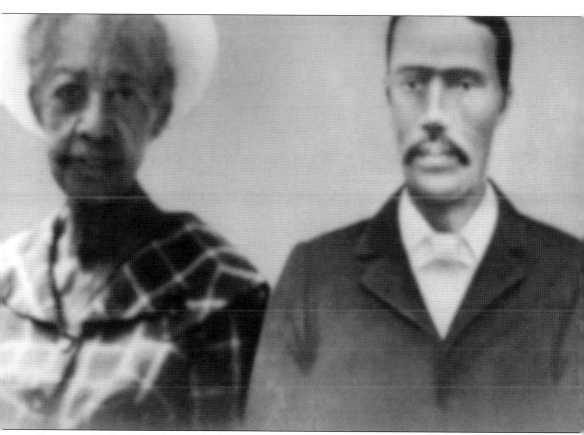

Shown are Mollie E. Hodge-Smith and J. Frank Smith. Mollie E. Hodge was the daughter of Henry Hodge and Georgeanna Hodge and was born in May 1870 in Fayette County, Texas. During the latter part of the 1880s, Mollie Hodge married J. Frank Smith, who was born in July 1859 in Texas. They settled in Justice Precinct 4, Lee County, Texas, just south of Lexington, Texas, along Highway 77 in the Leo community and gradually migrated into the Doaks Spring community, a Texas Freedom Colony. (Courtesy Della Catley-Franklin.)

Lena Shields, born on August 10, 1902, was the daughter of Katie Rivers and Henry Shields. Lena married Arthur Byrd on December 26, 1918. In 1944, they lived in Houston, Texas's Fourth Ward. Fourth Ward was a Freedom Colony famously known as "Freedman Town." Her father worked for E.P. Stuermer in Ledbetter, Texas, hauling cotton to La Grange for shipping. He was known to be fluent in the German language. (Courtesy Katie Taylor and the Rivers family.)

Arellia Rivers was born on April 11, 1887, in Fayette, Texas, when her father, Thomas, was 24, and her mother, Chanie, was 20. She had one daughter in 1913. She died on June 19, 1978, in Los Angeles, California, at the age of 91 and is buried in Carson, California. (Courtesy Katie Taylor and the Rivers family.)

Ola Mae Brown, also known as Ola Mae Zapalac-Brown, was born on October 18, 1919, in Texas to Amanda Rem, aged 41, and John Henry Zapalac, aged 37. Her mother, Amanda Rem, was born on June 2, 1878, and married to Henry Brown. Amanda's father was named John, and her mother was named Elvira. She died in March 1926 in Ammannsville, Texas. Ola Mae's father, John Henry Zapalac, was born on September 1882 in Texas when his father, John, was 16 and his mother, Maria, was 15. John had six children with Elizabeth Zapalac and one child with Amanda Rem. He died on January 5, 1956, in Smithville, Texas, at the age of 83 and is buried there. His father, John H. Zapalac (1865–1926), was born in Moravia, and his mother, Maria Weisner (1866–1927), was born in Bohemia. In 1920, Ola Mae was five years old and lived in Holman, Texas, with her mother and stepfather Henry Brown. Henry and Amanda Rem Brown were sharecroppers and tenant farmers and raised their 10 children in Holman and the Ammannsville, Texas, area. (Courtesy Ancestry.com.)

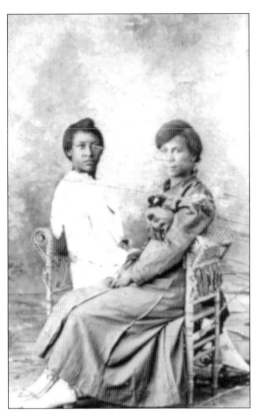

Beulah and Geraldine McNeil were the children of James and Pinkie McNeil, who lived in Lee County. James was born in 1858, and Pinkie was born in 1864. Both James and Pinkie were born enslaved in Texas. Beulah was born in 1903, and Geraldine, who was 18 years older, was born in 1885. Beulah was a schoolteacher and taught at Randolph High School, the Black high school in La Grange, Texas, that existed before integration. Below is a McNeal relative, Maggie Lee, born around 1907. (Left, courtesy Lena Katheryn McNeal-Smith; below, courtesy Ancestry.com)

Lt. Col. Reginald J. Sapenter, born on May 19, 1928, in Detroit, Michigan, married Dorothy Nell Collins on March 4, 1950. Dorothy was born in Lee County in 1932 to Travis Collins, a building construction worker, and Beulah McNeil Collins, a schoolteacher. (Courtesy Col. Reginald Sapenter.)

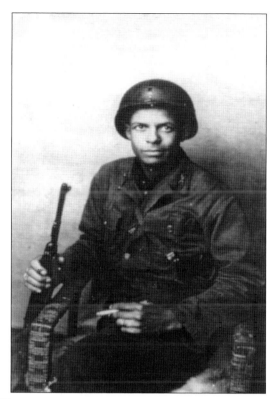

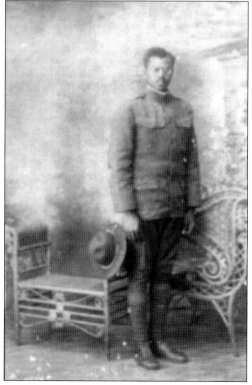

This unknown Rivers family ancestor was drafted and sent overseas during World War I. Over 700,000 African Americans registered for World War I, and 380,000 were sent overseas. Black soldiers served valiantly during the war, delivering supplies to the front line under dangerous conditions. The 371st Infantry Regiment was awarded the French Legion of Honor, acknowledging its bravery during combat. (Courtesy Vivian Francis.)

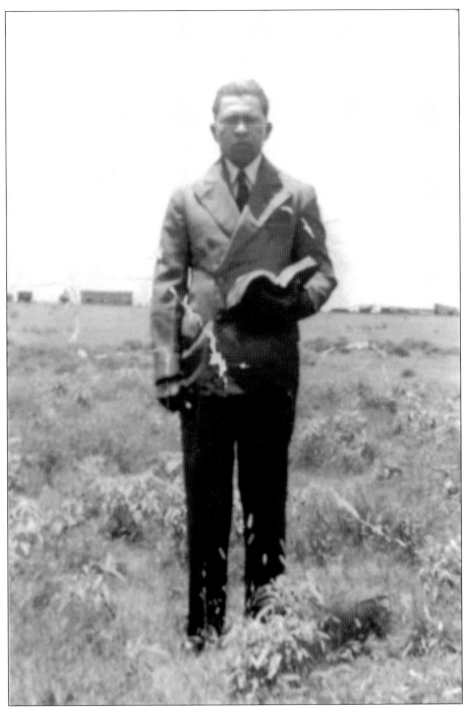

Herbert Mitchell was born in 1896 to Bessie Clemons and John Mitchell. When Bessie Clemons was born in May 1880 in Fayette, Texas, her father, Whales, was 50, and her mother, Sarah, was 45. Bessie married John E. Mitchell on December 5, 1895. They had seven children in 12 years. Bessie died on April 20, 1934, at the age of 53 and is buried in Burleson, Texas. Herbert was married to Lela Mitchell, who was born in 1912. (Courtesy Yulanda Fletcher.)

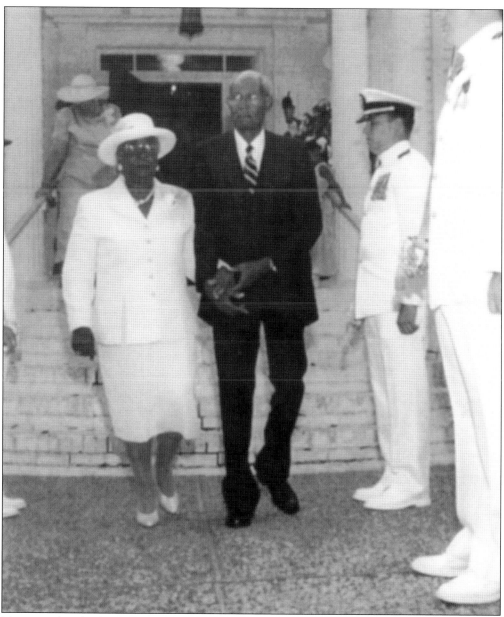

Maggie Taylor, the daughter of Wesley Taylor, was born in 1923 and married Doris Dunbar Collins, who was born in 1921. After being drafted in 1942 and doing his military training in Corpus Christi, Doris became a steward's mate and was shipped overseas to Manila, the Pacific Islands, and Samoa, where he served on a naval hospital ship named the *Refuge*. Doris had a front-row seat to the occupation of Tokyo. His ship was a few miles out when the United States dropped the atomic bomb, and he remembered seeing the smoke drift up into the air from the bomb. Doris was part of a Black World War II team of Seabees who were tasked with cleaning up Hiroshima and Nagasaki. After being out to sea for about five days, his ship landed on the shores of Tokyo, where he set up camp with a tent and a mosquito bag bed with a little mattress. It took the Seabees crew eight weeks to do the cleanup before returning to San Francisco in October 1945. Doris's grandson is a 1995 Annapolis graduate.

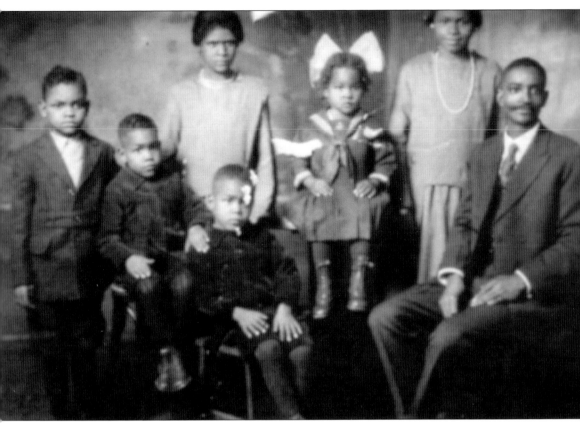

Shown is a 1922 picture of the Ben Catley family. When Ben Harrison Catley was born on November 8, 1888, in La Grange, Texas, his father, James, was 55, and his mother, Irene, was 41. He married Mary Lou Dowell, and they had eight children together. He also had one son and one daughter from another relationship. He died on January 23, 1965, at the age of 76 and was buried in Youngstown, Ohio. (Courtesy Della Catley-Franklin.)

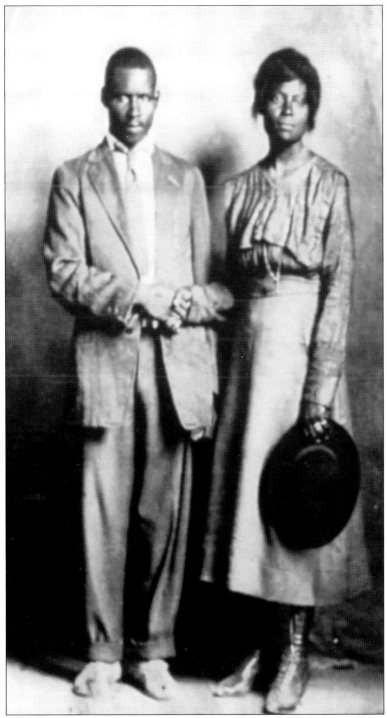

Arthur King (?) and Mary P. Tutson married on December 8, 1919, in Fayette County, Texas. Mary's father, Robert Tutson, was born in May 1886 in Fayette, Texas. Mary's mother was Wella Mort. Robert Tutson also had one daughter from another relationship. He died on April 27, 1941, in Fayetteville, Texas, at the age of 54 and is buried there. (Courtesy Beatrice Crump-Rivers.)

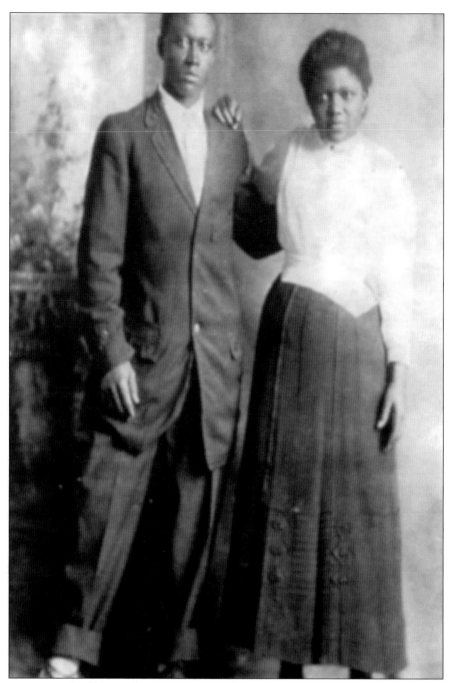

This is a picture of well-dressed George Hayes and Arizona Wolford. They were early Round Top pioneers. When George Hayes was born on October 6, 1892, in Fayette, Texas, his father, John, was 23, and his mother, Sallie, was 17. He married Aurelia James, and they had one son together. He also had two sons and five daughters with Lena Hays. He died on October 13, 1979, in Houston, Texas, at the age of 87. When Arizona Wolford was born in 1899 in La Grange, Texas, her father, Bradford, was 26, and her mother, Callie, was 29. She had one son with David Crump in 1919. She died in 1999 in her hometown at the age of 100. (Courtesy Beatrice Crump-Rivers.)

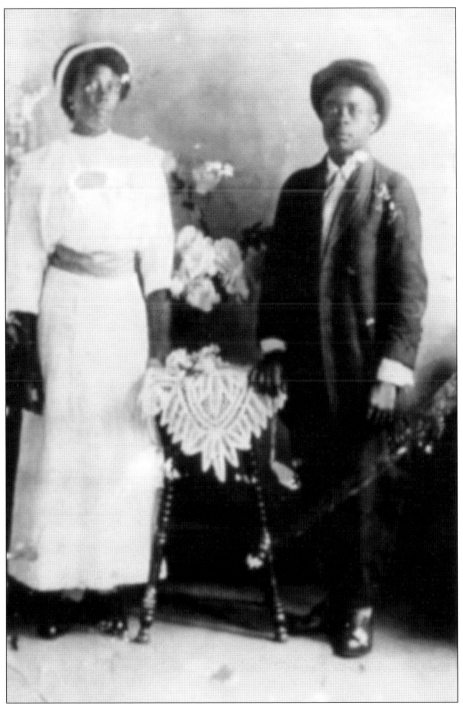

Shown are Classie and Nealey Washington. Nealey was born on March 16, 1896, in Round Top, Texas, and Classie was born around 1900, the child of Millie King Massey, born in 1872, and her second husband, Frank Massey, born in 1870. They were married in Fayette County, Texas, on May 28, 1915. By 1920, they were a young farming couple with two young children: John, born in 1916, and Nealey Jr., born in 1918. (Courtesy Beatrice Crump-Rivers.)

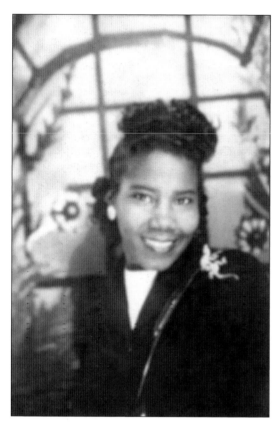

Janie Brown was born on August 3, 1924, in Texas when her father, Abram, was 48, and her mother, Lavata Bradshaw, was 39. She had one son and one daughter with Ferris Collins. Ferris, the author's uncle, attended the Round Top Colored High School prom in 1956. Janie died on April 7, 2012, in Round Rock, Texas, at the age of 87 and is buried in Giddings, Texas. (Courtesy Miltrue Cotton-Collins.)

Katie Mae Taylor was born on February 4, 1916, in Texas. Her father, Wesley Taylor, was 29, and her mother, Josephine Little, was 29. Katie married Horace Greeley Griffin on December 9, 1935, in Lee, Texas. She had many memories of growing up near Ledbetter, Texas. She is an African American Ledbetter historian and contributed to many of the contents of this book.

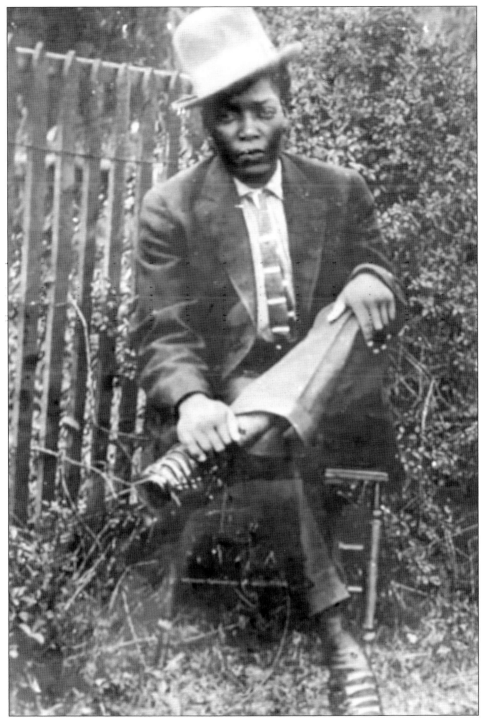

Annie Little (pictured) was born on September 5, 1893. Her father, Willie, was 29, and her mother, Narcisse, was 30. She had three brothers and two sisters. Her sister Josephine Little-Taylor was the grandmother of the author and wife of Wesley Taylor. Her brother William Roderick Little ran the only blacksmith shop in Ledbetter, Texas. (Courtesy Hattie Mae-Taylor-Adams.)

This is the picture of the fashionable, well-dressed Emma Daniels, who was one of the descendants of an early Round Top enslaved pioneer. This is one of many photographs taken by Beatrice Crump-Rivers of Round Top and Houston, Texas. She loved taking pictures of her churchgoing friends while living in Round Top. (Courtesy Beatrice Crump-Rivers.)

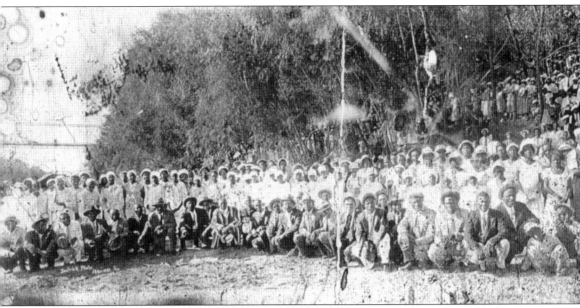

Maude Craft-Cole was a longtime church secretary of the Concord Missionary Baptist Church, founded in 1867. This is probably a May Day celebration or baptismal ceremony somewhere in the backwoods. The author remembers such celebrations growing up. This photograph was signed "Weimer" and was probably taken in Weimer, Texas. (Courtesy Maude Cole.)

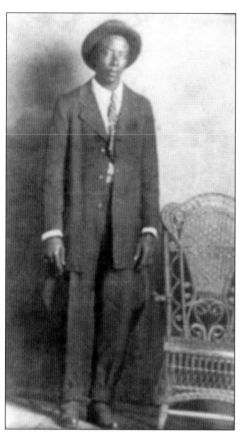

Benjamin G. Collins was born on January 21, 1896, in Texas. He married Ammie Hayes on May 30, 1921, in Fayette, Texas. They had four children during their marriage. He died on May 15, 1971, in Fayetteville, Texas, at the age of 75. Based on his military records, he was born in Oldenburg, Texas, just south of Round Top. He listed his house address as "R.F.D., Round Top, Texas." (Courtesy Maude Cole.)

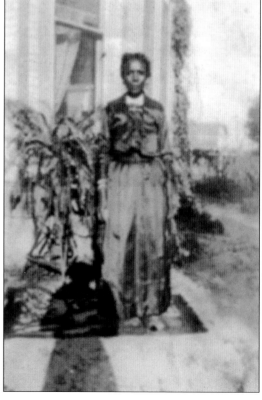

This is an unidentified Round Top resident from the Beatrice Crump-Rivers collection. She seems to be standing next to a beautiful palm tree. A beautiful climbing ivy plant can be seen on the outside wall of her home. She stands on a nice rug and is dressed stylishly in her Sunday best. The photographer's shadow is prominent in this picture. (Courtesy Maude Cole.)

Katherine L. Dobbins was born on April 18, 1875. She was the child of John Dobbins and Elmora Solomon. John was a farmer who was born enslaved in Fayette County, Texas, in about 1848. His wife, Elmora, was born enslaved in Tennessee in 1855. The family's nickname for Katherine was "Kittie." (Courtesy Della Catley-Franklin.)

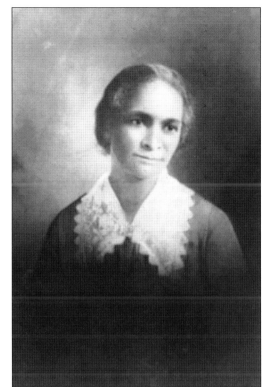

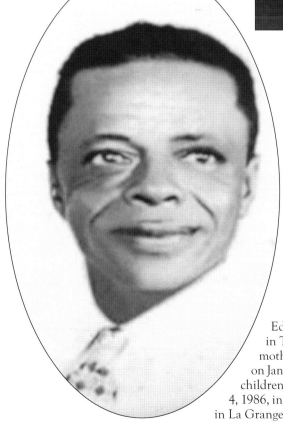

Ednar Dobbins was born on March 6, 1899, in Texas when his father, John, was 26 and his mother, Annie, was 17. He married Hettie Catley on January 8, 1927, in Fayette, Texas. They had two children during their marriage. He died on August 4, 1986, in his hometown at the age of 87 and is buried in La Grange, Texas. (Courtesy Ancestry.com)

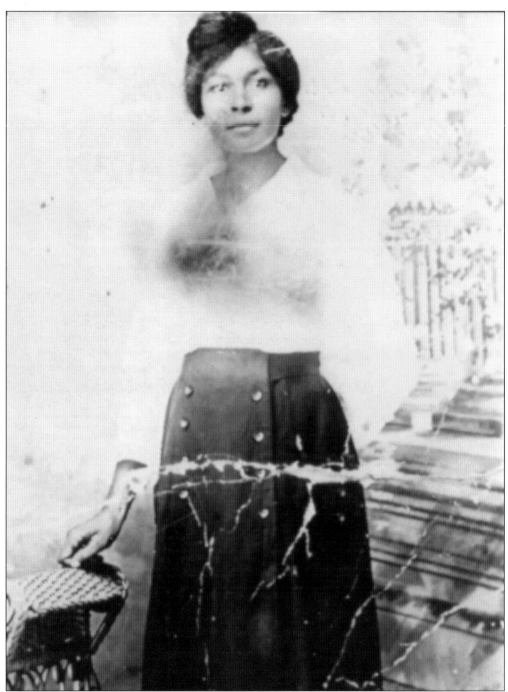

Eliza Shepard was born on August 3, 1878, in Winchester, Fayette County, Texas. Her father was Sam Shepard, and her mother was Sarah Gregory. Her siblings included Mahala and Adoph Shepard, and all of them were born in Winchester. During the time the Shepard family lived in Winchester, their neighbors were the Wares, Fosters, Gregorys, Bundicks, Browns, Penns, Sims, and Mainans. In the early 1890s, the Shepards had apparently moved to Lee County, Texas, where Eliza met Henry Clemons, and they married on July 17, 1894. (Courtesy Yulanda Fletcher.)

Rubye Mae Taylor was born on February 9, 1919. She was a 1941 bachelor of science home economics graduate from Prairie View College and taught school all over Texas. Rubye married William M. Collins on June 5, 1943, while he was finishing his master's degree in sociology and psychology, and they raised four sons. In 1956, the family moved to Ithaca, New York, where William received a doctorate from Cornell University in 1957. Afterward, the family returned to Texas. (Courtesy Pamela Collins.)

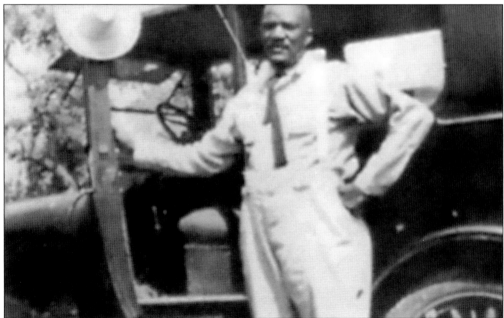

Willie Taylor was a member of the Taylor family whose ancestors were enslaved on Christopher H. Taylor's plantation. Willie was born in 1898 to Willie Taylor, born in Virginia in 1872, and Mary Taylor, born in Alabama in 1875. (Courtesy Della Catley-Franklin.)

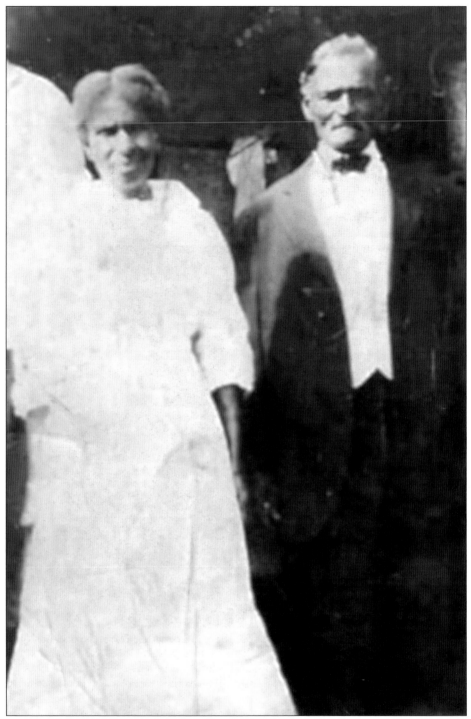

Shown are John Dobbins and Elmore Dobbins. John, born enslaved in Texas in 1848, was one of Fayette County's newly freed men who, by 1880, had managed to make a comfortable life for himself by farming. He was married to Elmore, who was born enslaved in Tennessee in 1855. The couple settled in Winchester, Texas, post-slavery. (Courtesy Della Catley-Franklin.)

Josephine Little-Taylor was born on October 30, 1886, in Ledbetter, Texas, the daughter of Willie Little and Narcisse Nunn. She married Wesley Taylor on July 11, 1911. She died on March 29, 1967, in Houston, Texas. Her brother William Roderick Little was a well-known blacksmith in Ledbetter, Texas, for many years, and the family still owns the plot of land in Ledbetter where his shop was located.

ROUND TOP NEW

David Collins

ow Your Neighbors

If not for the introduction by
ggy Warnock and Georgia Tubbs,
may never have known about
vid Collins, whose family traces
k to the early 1830s in this area.
recently spent a dreary, wet
urday morning with this fascinat-

ing man and within 15 minutes into
this interview, the weather was no
longer an issue. I mean, I can trace
my family to maybe my great grand-
mother on the mothers' side with
some clarity but that is about it.
This man knows the history of his
family for about nine generations
and it is in complete detail.
Although David officially does not
live in Round Top, his historical
presence is so strong I hope you will
forgive me the allowance I have
made to this feature. He is becom-
ing more and more recognized in
Round Top as he has been a driving
force in getting the Connersville
Primitive Baptist Church moved to
the Round Top Historical Society
Woods' Annex complex in hope of
providing a black history museum
for this area and Fayette county. All
of his ancestors were a part of the
living history of 1800s Round Top
and Fayette County. His ancestors
are Tom Rivers, Wesley Taylor,
John Wesley Taylor, Willie Will
Little, Wales Clemons, Elijah L.
Griffin, Richard Collins and Thomas
Henry Monroe Huff. Those of you
who know your history of this area,
will recognize the importance of
those names. For example in the his-
tory he has gathered, Tom Rivers
was born in 1810 in Alabama. He
married Jane Doe born in 1812 also
from Alabama. They had children

Rivers lived on what is
Wagner's Farm on Hwy
traces the Rivers family
until now and also has th
for all his other ancestors
through the research he h
this area that he became
the Round Top Historica
and has provided valuable
tion to this group. His fa
on tracts of land all
Cummins creek that has b
mensed throughout the 1
sus. They worked as far
grew cotton and hay, tend
and hogs but after the Civ
family became share crop
began moving into the Joh
league in the Dimebox ar
county. David himself gr
Doaksprings near Dimebo
10 brothers and sisters. H
Maggie Taylor still lives t
David grew up on the fa
1940s. During WWII so
family moved to Freer
the ammunition plants. T
children stayed on the far
cotton and tend to the far
moved to Houston in 195
school and then college. H
civil engineer and has his o
PTL, Inc., employing more
engineers. He has been pr
the school board for
County, member of the Te
of Health, received the Ge

The author was highlighted in a newspaper article from the *Fayette County Record* newspaper on March 10, 2006, in an article that talks about David Collin's family history of nine generations. It also mentions his contribution to being the driving force behind getting the Connersville Baptist Church moved to the Round Top Historical Society Woods' Annex complex. David's family roots run deep in Round Top through his ancestors Tom Rivers, Wesley Taylor, John Wesley Taylor, Willie Will Little, Whales Clemons, Elijah L. Griffin, Richard Collins, and Thomas Henry Monroe Huff.

While attending a Houston African Chamber of Commerce meeting, an attendee asked the author where he was from, and the author responded, "Texas." The member disagreed, believing the author had to be from Africa due to his West African features. The author's DNA test confirmed what the chamber attendee said—he is 44 percent Nigerian.

David L Collins, Sr. DNA Story
May 19, 2023

DNA Orgin/Country	Percentage	Notes
Nigeria	44%	
Cameroon, Congo & Western Bantu People	14%	
Benin & Togo	11%	
Mali	6%	
Ivory Coast & Ghana	6%	
Sweden & Denmark	4%	
Ireland	4%	
Senegal	3%	
England & Northwestern Europe	3%	
Wales	3%	
Nigeria-East Central	1%	
Southern Phillipines	1%	
Additional African American communities		
Early North Carolina		
Deep South		
Alabama & Mississippi Area		
Northeast North Carolina & Virginia Border		
Northwestern Coastal Plains		
East Texas & Oklahoma		
South Central Texas		
Burleson, Lee & Washington County		
South Texas		
Lee, Fayette & Bastsrop County		

This Round Top history ends where it began starting with the inspiration for this book, Esteban the Moor. Shown is a plaque in Corpus Christi that honors Esteban.

DISCOVER THOUSANDS OF LOCAL HISTORY BOOKS FEATURING MILLIONS OF VINTAGE IMAGES

Arcadia Publishing, the leading local history publisher in the United States, is committed to making history accessible and meaningful through publishing books that celebrate and preserve the heritage of America's people and places.

Find more books like this at
www.arcadiapublishing.com

Search for your hometown history, your old stomping grounds, and even your favorite sports team.